P9-DGS-973

Jennifer Bartlett

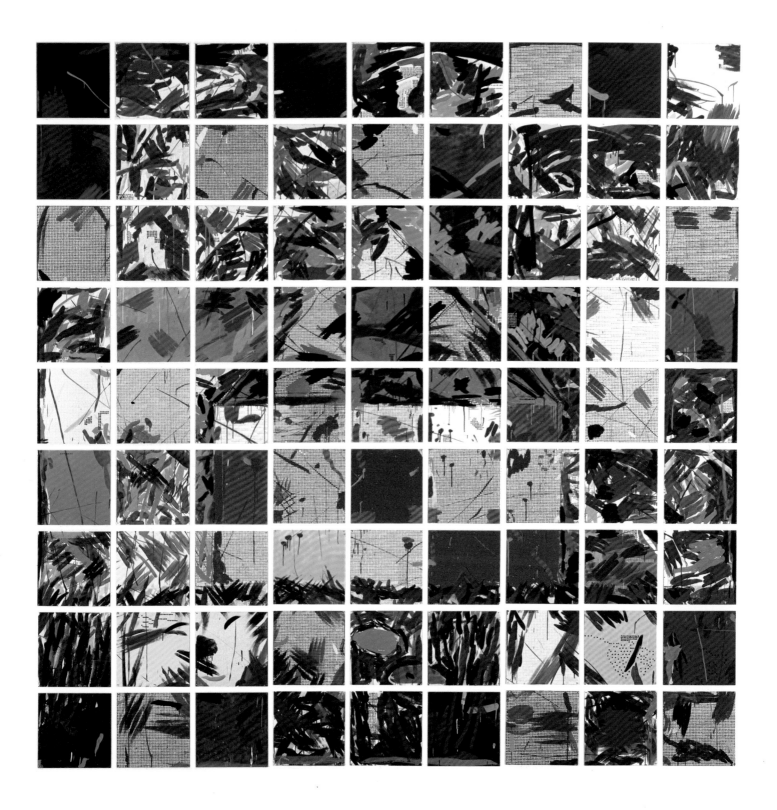

Jennifer Bartlett

Marge Goldwater
Roberta Smith
Calvin Tomkins

Walker Art Center
Minneapolis

Abbeville Press
Publishers New York

Unless otherwise indicated,
all dimensions are in inches.
Height precedes width precedes depth.

(cover)
At Sea, Japan 1980
detail
watercolor, gouache on 6 sheets of paper
22½ x 95¼
Collection Metropolitan Museum of Art,
Kathryn E. Hurd Fund, 1983

(frontispiece)
17 White Street 1977
baked enamel and silkscreen grid,
enamel on steel plates
81 plates
116 x 116
Saatchi Collection, London

(p. 6)
Boy 1983
oil on 3 canvases
84 x 180
The Nelson-Atkins Museum of Art,
Gift of the Friends of Art

This publication was prepared on the occasion of the exhibition *Jennifer Bartlett,* organized by Marge Goldwater, Curator, Walker Art Center, under the direction of Martin Friedman.

The organization and national tour of *Jennifer Bartlett* have been supported by grants from the National Endowment for the Arts and the Dayton Hudson Foundation for B. Dalton Bookseller, Dayton's and Target Stores.

Additional funding was provided by The McKnight Foundation, the General Mills Foundation, the Bush Foundation, and the Minnesota State Arts Board.

Library of Congress Cataloging in Publication Data

Goldwater, Marge
Jennifer Bartlett

Bibliography: p. 163 Includes index. 1. Bartlett, Jennifer, 1941- . I. Bartlett, Jennifer, 1941- . II. Smith, Roberta. III. Tomkins, Calvin. IV. Walker Art Center. V. Title.
ND 237.B275G65 1985 759.13 84-51359
ISBN 0-89659-519-6 (Abbeville Press)
ISBN 0-89659-527-7 (Abbeville Press: pbk.)

Contents

7 Foreword
Martin Friedman

9 Drawing and Painting
Calvin Tomkins

39 Jennifer Bartlett: On Land and at Sea
Marge Goldwater

79 Flooding the Mind and Eye:
Jennifer Bartlett's Commissions
Roberta Smith

139 Plates

159 Exhibition History

163 Bibliography

166 Acknowledgments and Lenders

168 Index of Illustrations

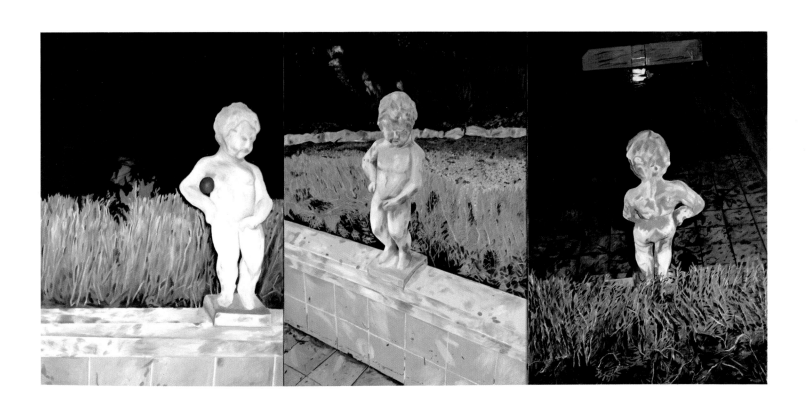

Foreword

One late winter afternoon in 1972, I was taken to see the work of a young painter who was beginning to attract attention for her distinctly idiosyncratic approach to picture-making. A quick glance around the studio revealed walls covered with fastidiously defined grids on license-plate-size plaques of white enamel on which appeared colored dot configurations that suggested landscape elements. In Jennifer Bartlett's technique, at that time a curious fusion of late nineteenth-century Pointillism and mid-sixties Minimalism, a few basic images were repeated, sometimes with subtle variations of form and color. Whatever their stylistic affinities, it was clear that her vibrant chromatic squares were in a category of their own. Although her painting was almost obsessive in its methodology — it verged on the mechanistic — an unmistakable romanticism underlay these works.

As a result of that studio visit, the Walker Art Center acquired *Series VIII (Parabolas)*, a handsome configuration of thirty-six painted metal squares filled with sinuous shapes, formed of orderly daubs of paint that alluded to land, sky and water.

In 1972, a group of Bartlett paintings was included in the Walker Art Center's exhibition *Paintings: New Options*, her first museum showing. Her infatuation with light, color and shimmering surfaces, so apparent in the early grids, has remained the unifying element as her painting evolved from its dotted analytical phase to its lavishly brushed estate. Throughout this artistic evolution, the landscape motif remains dominant.

Jennifer Bartlett's artistic journey has been scrupulously charted in this exhibition assembled by Walker Art Center Curator Marge Goldwater, whose understanding of the artist's work is admirably reflected in the selections she has made and in the illuminating commentary she has written for this publication.

It is a privilege to present Jennifer Bartlett's paintings in Walker Art Center's galleries and to make this exhibition available to our sister institutions, The Nelson-Atkins Museum of Art, The Brooklyn Museum, the La Jolla Museum of Contemporary Art and the Museum of Art, Carnegie Institute.

Martin Friedman, Director

Drawing and Painting

Calvin Tomkins

Jennifer Bartlett's New York friends are often surprised to learn that she grew up in southern California. How could that laid-back, sybaritic culture (as outsiders tend to view it) have produced an artist of her energy, analytic rigor, and undissembled ambition? Bartlett herself says that California always seemed strange to her. When she was five years old she told her mother she was going to be an artist and live in New York. Although she now lives part of the time in Paris, in order to be with her husband, the film actor Mathieu Carrière, New York has been her real home for the last fifteen years, and her aesthetic home for a lot longer than that.

The art world becomes more diversified all the time, of course, and Bartlett's career reflects that. As one of the most widely exhibited artists of her generation (the generation that emerged in the late 1960s and the early 1970s) she is well known in Tokyo and in London, where her disconcertingly direct manner, her helmet of close-cropped dark hair, and her habit of cracking jokes at her own expense lead most people to assume that she must be a native New Yorker. Nevertheless she did grow up in Long Beach, California, and her childhood there, as the oldest in a family of four children, seems to have been a reasonably conventional one. It was her response to it that was unusual. Born in 1941, she put in enough time at surfing beaches and on the sidelines of various athletic fields (she was briefly a cheerleader at Long Beach High) to become permanently dubious about male supremacy — a trait that would prove useful to her when she went to Yale. Her father, Edward Losch, was a

pipeline construction engineer whose earnings fluctuated from year to year. The family's mode of living fluctuated accordingly, but most of the time they were able to consider themselves in the upper-middle class. Her mother had been a commercial artist, a fashion illustrator; she quit work when Jennifer was born. Jennifer went to the vast public schools of Long Beach, where she quickly established herself as the class nonconformist, arguer, and artist. "I never had the kind of natural talent that lets you draw portraits of horses or things like that," she remembers. "I'd do very large drawings on brown paper that showed, for example, everything I could think of underwater. Or scenes with people dropping from cliffs into boats, and Indians in the background. Art teachers always liked me, but I never really understood why what I did was good." In addition to drawing constantly, she developed an early passion for reading — stories and novels of all kinds. Sometimes her reading took the place of her school assignments. Told to read one thing and write an essay on it, she would read something entirely different and write about that. For a while in her teens she thought about becoming a lawyer, because she was so good at arguing, but otherwise she did not waver significantly from her five-year-old decision to be an artist.

The decision was reconfirmed at Mills College in Oakland, California, which she entered in 1960. Although known as "the Vassar of the West," a place for young women of the best families, Mills had a strong art department and an even stronger music department, both of which were open to advanced contemporary work. Fernand Léger, Max Beckmann, and Clyfford Still had all taught in the graduate school there at various times (Still quite recently), and the work of the New York Abstract Expressionists of Still's generation was hotly discussed. Jennifer Losch absorbed a wide variety of aesthetic influences and began painting in a loose abstract style derived mainly from the work of Arshile Gorky. She had her first one-person show at Mills in 1963, her senior year. The reactions to it were mixed, but the slides she made of some of the paintings were impressive enough to get her into the graduate art program at Yale, which happened to be (although Bartlett did not know it then) the best possible place just then for an ambitious art student.

Yale's popular reputation as an incubator of stockbrokers has sometimes obscured its strength in fields that other Ivy League schools

have barely begun to cultivate. The graduate School of Art and Architecture, founded in 1869, is an example. Teaching standards there have always been on a high and thoroughly professional level. In 1950 the school's fine arts program came under the direction of Josef Albers, the former Bauhaus teacher who had established his American reputation at Black Mountain College in North Carolina. Albers changed the program's conservative direction, putting the emphasis squarely on modern art and bringing in as guest teachers distinguished contemporary artists with widely divergent approaches: Willem de Kooning, Stuart Davis, Burgoyne Diller, José de Rivera, Ad Reinhardt, and James Brooks, among others. As a result, Yale in the 1950s became a mecca for the most adventurous art students. Albers retired in 1958, but the program continued to attract many more students than it could accommodate (one out of twenty applicants got in). When Jennifer Losch arrived, in the fall of 1963, Jack Tworkov had just taken over as the school's new chairman. Tworkov was a well-known New York painter, one of the first generation of Abstract Expressionists. Unlike some artists of that generation, he took a lively and supportive interest in the work of Robert Rauschenberg, Jasper Johns, Frank Stella, and other young people who were finding new paths, and he invited a number of them to Yale as guest teachers. Tworkov oriented the school primarily toward New York and its rapidly expanding art world. Midtown Manhattan was less than two hours away by car, and the students went down regularly to visit the galleries and the museum shows. The art world, a small and tightly knit fraternity until the mid-1950s, was opening up to all sorts of new influences — new art forms, new galleries, and a new public whose interest was whetted by rising prices and by the controversy surrounding Pop art. For the first time in many years a career in art began to seem like something more than a quixotic gamble. Among Yale's highly competitive art students, the feeling was very strong that they were "the next generation" in contemporary art; they used to joke that the New York art world was an extension of Yale. "There was no question in our minds that we would be showing at Leo Castelli's any day," Bartlett recalls. "I remember hearing that Larry Poons had had his first show at Leo's when he was twenty-six, and it was perfectly clear to me that if I hadn't had a show by the time I was twenty-six, I was quitting."

A number of the students who got their BFA or MFA degrees, or both, at Yale when Bartlett was there did become important figures in contemporary art: Richard Serra, Chuck Close, Jonathan Borofsky, Nancy Graves, Rackstraw Downes. One of the interesting things about this generation of artists is that so many of the good ones are women. The feminist movement of the early 1970s had a lot to do with the increasing recognition of women in art, but the movement had not surfaced when Bartlett was a student. Male supremacy was still the norm at Yale, and she reacted to it with considerable anger. "I adopted a completely macho attitude of my own," she told me. "I was terrified my first semester, but then I just started building huge stretchers that interfered with the people working near me." She also got married. Edward Bartlett, a fellow student at Mills, had come east with her to enter Yale Medical School; they were married during their first year there and moved into a small apartment off campus in New Haven. Neither of them had much time to devote to the marriage. Jennifer painted day and night, big splashy canvases that were still mainly Abstract Expressionist. Occasionally one of the male students would infuriate her by saying you'd never know they had been painted by a woman.

She took her BFA degree in 1964 and her MFA in 1965. Ed Bartlett still had two more years of medical school, so instead of moving immediately to New York, Jennifer got a job teaching art at a branch of the University of Connecticut in Storrs, which was nearly two hours north of New Haven. She went to New York every chance she got, though. After three years of this, she rented a small loft for herself on Greene Street, in the part of downtown Manhattan that would soon be called SoHo but was then a grimy, rundown industrial area where abandoned loft space could be rented cheaply. She commuted to Storrs from there during the week; on weekends she went to New Haven to see her husband, or he came to see her in New York. It was an exhausting schedule, but being in New York made up for it. She never even considered going back to California. "I didn't think it was possible to be a serious artist there," she told me. "And anyway I was just crazy about New York. I remember the first time I got there, being knocked down by a big, fat woman when I was trying to hail a taxi — for some reason this appealed to me enormously."

She had a built-in network of friends. Elizabeth Murray, an artist who had been her best friend at Mills College, had moved to New York

the year before. Jonathan Borofsky had a loft just down the block on Greene Street, and Barry LeVa, who had been in her class at Long Beach High and who was just becoming known as a conceptual artist, lived not far away. Through them she got to know most of the young artists in New York and kept in touch with all sorts of new developments. The opening-up process of the early 1960s had led to a bewildering proliferation of experiments, styles, and ideas. Minimalism, which started at about the same time as Pop, in the early 1960s, but took longer to gain recognition, was on its way to becoming the dominant style of the 1970s; many young artists, influenced by Frank Stella's stripe paintings and Donald Judd's metal box sculptures, were trying to reduce painting and sculpture to their essential elements of shape, color, and volume, and to do so in ways that removed all traces of the artist's personal touch or sensibility. Others were moving in different directions: using the Nevada desert or their own bodies as art material (earth art, body art), investigating language in its relation to art (art and language), or shedding the notion of the art object altogether and devoting their attention to mathematical, linguistic, or philosophical concepts that sometimes did not take any material form (conceptual art). Some of this activity seemed to be a reaction against the increasing commercialization of the art world, although even the earth artists, whose labors in the desert and elsewhere looked like noncommercial ventures of the purest kind, were not averse, it turned out, to having the photographic evidence of these works offered for sale in commercial galleries. It was a period of great uncertainty and confusion. Dozens of young artists were searching for the unique something that would single them out above the crowd — the new image, the new material, the new mode of expression.

"I liked all of it," Bartlett recalls. She wanted somehow to take it all in — not just the newest trends but also the work of artists who had already made their mark. Among the artists she and her friends admired the most was Jasper Johns, but this did not prevent her from getting into heated arguments with Johns when they met. "Jennifer was sort of a brat," Elizabeth Murray has said. "She was outspoken and seemed very sure of herself, and she made people angry, especially men." The sort of work that Bartlett was doing then struck Elizabeth Murray as "unfathomable." Some of it looked like process art, a form that made use of nonart material in ways that emphasized the processes through which

they could become art. For Bartlett, though, the process had to do mainly with her living in New York. She bought cheap merchandise from the secondhand outlets on Canal Street — quantities of red plastic sugar bowls, for example, which she subjected to various ordeals: one was dropped from a fourth-floor window; another was left outdoors for a week; a third was left outdoors for a month; a fourth was baked in an oven for ten minutes at three hundred degrees, and so forth. At the end she set them all out on the floor of her loft, in a temporary tableau. She made a series of wall hangings out of stretched, interlaced canvas straps (the kind of straps people use to tie up their suitcases or trunks). She also painted, and she made a great many drawings — colored dot drawings on graph paper, which often seemed to her the most interesting things she was doing then. In addition she started to write. Some of the conceptual artists appeared to be more interested in words than in visual images; Bartlett feels that she might actually have become a full-time writer — writing seemed easier to her than painting. She wrote a long four-part essay called "Cleopatra" (it was published in 1971 by Adventures In Poetry, a small New York press), after which she commenced work on her autobiography, an open-ended document that would eventually turn into a thousand-page autobiographical novel called, self-mockingly, *The History of the Universe*. Trying out all these forms and moving in several directions at the same time tended to put her at a disadvantage among her peers, most of whom had charted what they hoped was a unique course and were sticking to it. She usually found herself on the defensive when talking with the artists at St. Adrian's or the other downtown bars where they gathered. "People had very definite opinions," she remembers, "and everybody was terrifically competitive. I imagine there were very few people doing abstract work who were acceptable to Brice Marden, and very few people doing sculpture who were acceptable to Richard Serra. I didn't really have a point of view like that. I liked a lot of different work."

Few of the artists of her generation were making money from their art. They supported themselves any way they could — carpentry, bartending, teaching. Bartlett was still commuting to the University of Connecticut at Storrs. Her teaching methods were unpredictable. After criticizing a student's failure to utilize the whole space of a canvas, to "make every inch count," as she had been told to do at Yale, it occurred

to her that maybe it would be interesting to have some blank space around the image after all, so she had her students try that. One of the problems in her own work was that other people's ideas interested her too much; she had a lot of trouble thinking up her own. Her best ideas always came out of the actual process of working. She felt that if she could find a new method that involved a great deal of physical work, a "labor intensive" method, she would be better off. "I was looking for a way to get work done without the burden of having to do anything good," she told me. "I wanted desperately to be good, of course, but whenever I sat down and tried to think of something that would be terrific to do, I couldn't."

At this point, late in 1968, she hit on the notion of using steel plates as the basic module for her paintings. The minimal artists often used modular units, but Bartlett's idea had nothing to do with minimalist sculpture, or with philosophical meditations on "the object." She wanted a simple, flat, uniform surface to paint on, a surface that did not require wooden stretchers, canvas, and all the bothersome paraphernalia of oil paint. "I thought that if I could just eliminate everything I hated doing, like stretching canvas, then I'd be able to work a lot more," as she explained it later. She tried a number of different surfaces — wood, plastic, aluminum — before settling on one-foot-square steel plates that she had coated with a layer of white baked enamel (very much like the signs in New York subway stations, which is where she got the idea) and on which she then superimposed a silk-screened grid of light gray lines (suggested to her by the graph-paper drawings she had been doing). That all this had to be done for her by professional jobbers suited her fine. Bartlett is an exceptionally fastidious worker; some of the inspiration for the steel plates must have come from her abhorrence of mess.

The paint that she found to use on the baked enamel surface was Testors enamel, which is sold mainly in hobby stores for model airplanes and cars. It comes in twenty-five colors, in small bottles that can be recapped when not in use. Bartlett started out by limiting herself to four colors — yellow, red, blue, and green — plus black and white. "It always made me nervous just to use the primary colors," she told me. "I felt a need for green! I felt no need whatsoever for orange or violet, but I did need green. Of course I know that yellow and blue make green, but

View of 1972 exhibition
Reese Palley Gallery

detail

Nine-Point Pieces
baked enamel and silkscreen grid,
enamel on steel plates
9 plates each
38 x 38

(p. 18) clockwise from upper left:
Continental Drift 1974
Courtesy Paula Cooper Gallery

Traveling Line 1973
Collection Harold I. Huttas

Nest 1973
Courtesy Paula Cooper Gallery

Chicken Tracks 1973
Collection Dr. and Mrs. Peter W. Broido

(p.19) clockwise from upper left:
Nine-Point Plane 1974
Courtesy Paula Cooper Gallery

Edge Lift 1974
Collection Allen Memorial Art Museum,
Endowment Fund, Acq. #77.13

Enclosure Drift 1974
Courtesy Paula Cooper Gallery
51 x 51

2001 1973
Collection Neuberger Museum,
State University of New York
at Purchase. Gift of Martin J. Sklar

not really in the same way that yellow and red make orange. I just had to have green." She applied her colors in the form of dots, in strictly planned combinations and progressions. The sequence of colors was always the same: white, yellow, red, blue, green, black — but her combinations and progressions ran a gamut from simple to extremely complex. What she was doing *sounded* like conceptual art; she was using mathematical systems that determined the placement of her dots. But the results, all those bright, astringently colored dots bouncing around and forming into clusters on the grid, never looked conceptual. For Bartlett, the mathematical system was not important in itself; its only function was to provide a means of getting work done. The benefits came from the physical act of applying the paint, not from the system.

It was a great way to get a lot of work done. In 1970 she showed "about three or four hundred" painted steel plates (her memory is a bit vague here) in her first New York exhibition, at Alan Saret's loft on Greene Street. In those days Saret, an artist who has since become well known, occasionally turned his loft into an exhibition space for himself and others. Her next show was at the Reese Palley Gallery on Prince Street, in January 1972 (p. 16). Palley had a large space, and by then Bartlett had more than enough work to fill it — literally hundreds of enameled steel plates grouped together into multipart series paintings (in the show at Saret's each plate had been presented singly). In hanging the show she had left a two-foot space between each series, a one-foot space between the various sets of plates within a series, and a one-inch space between individual plates. These separations tended to get overlooked in the total effect, which was of a large room entirely filled with colored dot paintings in a mind-boggling display of patterns. Although most of the patterns were abstract, she had also included a very large painting (p. 44) in which a rudimentary but clearly recognizable house — a square with a triangle on top — appeared in many different aspects and in a wide range of colors that suggested different times of day and different seasons of the year. A lot of people saw the show. There were even a few sales and a favorable review in *Art News* by Laurie Anderson, who was just getting started then as a performance artist and who supplemented her income by writing gallery notes.

During the next year and a half Bartlett continued to pour her energy into diverse activities. In 1972 she got a job teaching at the School of Visual Arts in downtown Manhattan, which meant she could

quit commuting to Connecticut. She did a lot of painting, and her work was included in several group exhibitions outside New York. Her auto-biographical novel, meanwhile, was getting longer and longer, its pages of personal history interspersed with brief prose portraits of friends, lovers, members of her family in Long Beach, fellow artists, chance acquaintances. She was divorced from Ed Bartlett by this time. One of her closest friends was Paula Cooper, whose portrait in the novel is very admiring. Bartlett had given readings from her novel at the Paula Cooper Gallery in SoHo and she made no secret of her desire to show her work there. But Cooper had reservations about her work. She was a little put off by Bartlett's wanting to crowd so many paintings into a show, and also by her fairly blithe way of following a mathematical system until it became inconvenient and then bending it or simply dropping it altogether. She accused Bartlett of being a "nihilist" in this respect. Cooper admired very much the work of Sol LeWitt, the conceptual artist, whose first wall drawings (made directly on the wall) were done in her gallery. She felt that if you decided to use a mathematical system, as LeWitt and several other conceptualists did, then you were involving yourself in an investigation that became, in effect, the content of the work, and for this reason you had no business breaking the system. It took her a while to understand that Bartlett had no real interest in the system or the concept — that for her it was just a means. In 1974, at any rate, Cooper agreed to take her into the gallery and to give her a show in the spring.

The "nine-point" paintings (pp. 18-19) that Bartlett showed that spring were rigorously conceptual. She used only black and red dots this time. The placement of the nine red dots was identical on each one-foot square; it had been arrived at randomly by drawing numbered cards from a coffee can (one number for the horizontal line on the grid, another for the vertical). The black dots went down according to a variety of prearranged systems; they might connect one or more red dots in a straight line or descend vertically from the red dots (and then pile up chaotically at the bottom) or move about the grid in different directions. The general effect was somewhat austere and quite perplexing. One piece in the show, called *Squaring* (p. 43), had no red dots at all. It was a sequence of thirty-three plates, with 2 black dots in the two top left-hand squares of the grid on the first plate, 4 black dots on the second, 16

Nine-Point Pieces 1973-74
View of 1974 exhibition
Paula Cooper Gallery

Rhapsody 1975-76
baked enamel and silkscreen grid,
enamel on steel plates
988 plates
7 feet 6 x 153 feet 9
Collection Sidney Singer

(pp. 22-23)
Views of 1976 exhibition
Paula Cooper Gallery

(pp. 24-27)
Rhapsody 1975-76
details

on the third, 256 on the fourth, and then 29 more plates entirely filled with black dots, representing the square of 256. It was the kind of mathematical system that Bartlett enjoyed — mathematics' goofy side.

Several more group shows followed, in and out of New York. She went to Europe for the first time, for a gallery show of her work in Genoa and a two-artist show with Joel Shapiro, a good friend of hers, at the avant-garde Garage in London. Her medium was still Testors enamel on enameled steel plates, but it was no longer austere; she had begun to use more and more of the twenty-five colors, sometimes mixing or layering them to make new colors. In a work called *Drawing and Painting* (p. 8) that appeared in a group show at Paula Cooper's new Wooster Street gallery in the fall of 1974, some sections were done in colored dots while others were actually painted with a brush, obliterating the grid. She was getting ready to throw away the conceptual crutch.

During the summer of 1975 Bartlett arranged to house-sit for friends in Southampton, on Long Island's south shore. In exchange for taking care of the garden and the main house, she had the use of a small cottage on the property. She became so absorbed in her work that the garden dried up. Bartlett had laid in a large supply of her steel plates (more than a thousand) with which she planned to make a painting "that had everything in it." This idea had been knocking around in her mind ever since the Reese Palley show, in which it had been so difficult to tell where one picture stopped and the next began; the show might almost have been a single painting, she thought, except that it had not been planned that way. The notion struck her now that she could organize and orchestrate a really large work whose effect would be like the experience of a conversation, in which subjects were taken up, dropped, and then returned to in a different form, with many "voices" and interwoven themes. Since the conversation was to include "everything," she decided that it would have both figurative and nonfigurative images and that they could appear in small scale, on individual enamel squares, or spread out over a great many squares. She picked the first four figurative images that occurred to her: a house, a tree, a mountain, and the ocean (later she greatly regretted the tree, which she claimed to find banal, but she refused to alter her original decision). The nonfigurative images she chose were a square, a circle, and a triangle. There would also be color sections and sequences, sections devoted to lines (horizontal, vertical,

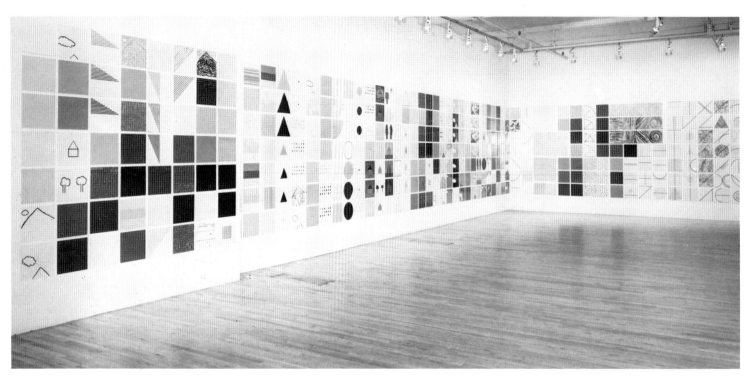

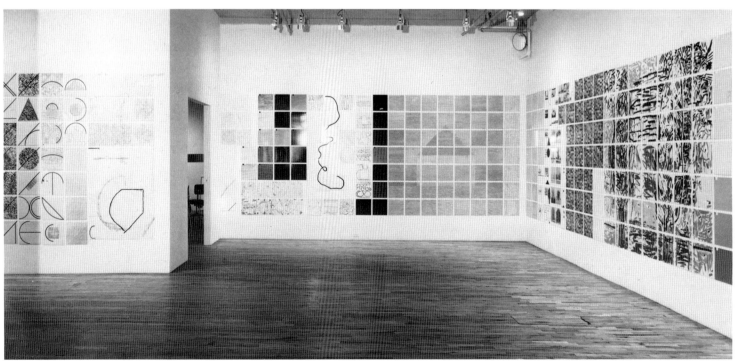

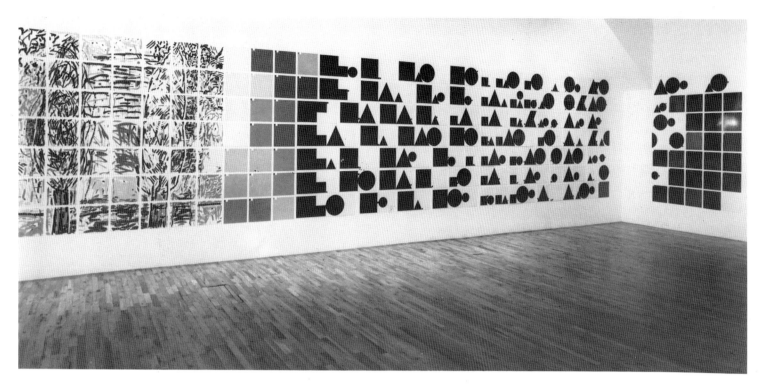

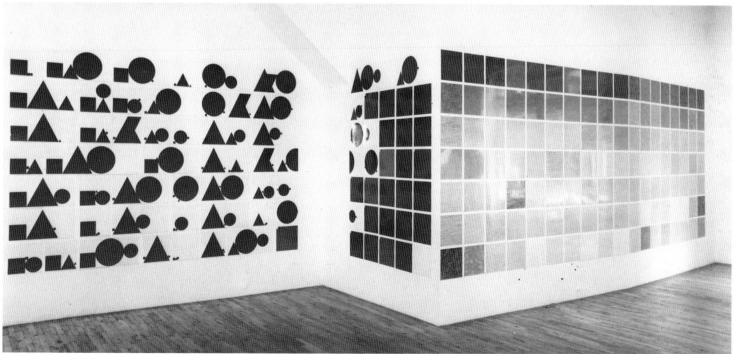

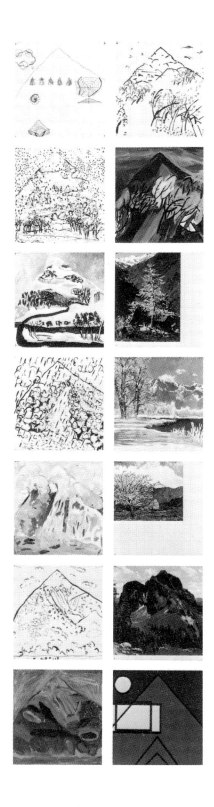

and curved), and several different methods of drawing (freehand, dotted, ruled). These and many other basic decisions were reached in her quarters in Southampton, including the decision that she would make up her mind about retaining or discarding a specific plate within one day of finishing it. "I didn't want to get involved too much with thinking about the piece," she told me. "If I didn't like what I'd done each day I'd just wipe it out. I wanted the piece to have a kind of growth that was actual rather than aesthetic."

She finished the first hundred-odd plates in Southampton and the rest — there were 988 in all — in her New York loft that fall and winter, often working twelve or fourteen hours a day. Many more hours were spent in library research. She read dozens of books on trees and dozens more on mountains. Although the figurative images she used were simple ones, she wanted to show an *essential* tree and an *essential* mountain (the peak she used was taken from a book on the Alps), and anyway she loved to read. The huge work was organized in sections, starting with the house (the same house she had used in the Reese Palley paintings) and culminating in the 126-plate ocean sequence, in which she used fifty-four shades of blue. References to the various motifs recurred throughout the work, which gathered complexity as it went along. The house, the tree, the mountain, the line and color sequences, the geometric shapes, the many different techniques of drawing and painting — all these and many more elements announced themselves individually and then began to work with one another in the continuity of the whole. Bartlett never saw the whole thing together until it was installed in Paula Cooper's gallery; her loft could accommodate only a third of the plates at a time. Sometimes it struck her as the worst idea she had ever had. When it was nearly complete, she still had not decided on a title. An English friend, the architect Max Gordon, said he thought the title should have some reference to music; he suggested calling it *Rhapsody* (pp. 22-27), and that appealed to Bartlett's self-deprecating sense of humor. "It was so awful I liked it," she said. "The word implied something bombastic and overambitious, which seemed accurate enough."

It took a week to install the 988 square plates at Paula Cooper's. Each plate was nailed to the wall, separated from those around it by exactly one inch on all sides. Although Bartlett had never plotted the measurements of the complete work, it filled the available wall space of

the gallery with almost mathematical precision. Word of the piece had been going around SoHo, and the gallery was crowded throughout the opening day, a Saturday in mid-May, 1976. Many visitors commented on the painting's strong narrative quality; unlike virtually all other contemporary painting, it was a work that you "read" from left to right, and in which you could easily get so absorbed that you lost your sense of time. Although *Rhapsody* was clearly an art-world "event," nobody was quite prepared for the lead article that appeared in the Arts and Leisure section of the next day's *New York Times*, in which John Russell, the *Time*'s chief art critic, described the piece as "the most ambitious single work of art that has come my way since I started to live in New York," a work that enlarges "our notions of time, and of memory, and of change, and of painting itself." Russell's glowing review was an art world event in itself, and the repercussions were large and immediate.

The gallery was closed on Sunday and Monday, but on Tuesday there was an even larger influx of visitors. At some point during that hectic morning, Paula Cooper took a telephone call from a man she did not know, who said his name was Sidney Singer. He wanted to know whether the work was still "available." Paula Cooper said it was, and he told her to hold it for him — he would be there in forty-five minutes. It had never occurred to Cooper or to Bartlett that the work could be sold intact, although a week or so earlier they had decided that it should not be broken up. On that Tuesday, however, Singer, a relatively new collector who lived in Mamaroneck, New York, arrived within the promised forty-five minutes and purchased the complete work. Paula Cooper persuaded him not to take possession of it until *Rhapsody* had been exhibited in a number of galleries and museums around the country.

Bartlett's life did not change dramatically as a result of this first major sale. She paid off a lot of accumulated debts and kept right on painting. She also continued to teach at Visual Arts and to write her autobiographical novel. Something very big had happened to her nevertheless. She had come into her own estate as an artist, and it had turned out to be a rather grand and impressive one. Bartlett had gained the confidence to trust her inclinations, which were neither minimal nor conceptual, and her work since *Rhapsody* has been a direct reflection of her unencumbered personality as an artist — lavish in scale, decorative, inclusive to the point of being omnivorous, frequently mocking or self-

Graceland Mansion 1977
baked enamel and silkscreen grid,
enamel on steel plates
80 plates
51 x 259
Collection the artist

mocking, wildly eclectic, and startlingly ambitious. She is a little like Robert Rauschenberg in her willingness to risk failure at every turn. Her mistakes are all made out in the open, and as often as not they are turned into assets. As she said to me the other day, "I've developed an infinite capacity for work and none for reflection."

The series of house paintings that followed *Rhapsody* — multipart renderings of the same rudimentary house image — expanded her repertory of painting styles. Impressionism, Expressionism, Neo-Realism, Rayonism, Van Gogh, Matisse, Pollock, Mondrian — sometimes the entire history of modern art seemed to be making a guest appearance in her work, without quite upstaging the host. Bartlett was creating a style out of borrowed styles (and doing so long before the current fad for "appropriation"). Her new house paintings were really portraits of people. Their titles came from the addresses of people she knew well (one was a list of addresses she herself had had), and most of them had some abstract visual reference to a particular person. In *17 White Street* (Elizabeth Murray's New York address) she used all twenty-five of the Testors colors (p. 2), to suggest the kind of "contained chaos" that she associated with her friend. The most impressive painting in this series

was named for Elvis Presley's Graceland Mansion because Presley, a childhood idol of Bartlett's, died while she was painting it. *Graceland Mansion* (pp. 30-31) is really five paintings hung in a horizontal sequence, showing the same symbolic house image from five different angles, at five different times of day (its shadow falling to the left or to the right), in five different painting styles. Bartlett's most famous print is derived from this painting. Called *Graceland Mansions* and published in an edition of forty, it is really five prints, each done in a separate technique: drypoint, aquatint, silkscreen, woodcut, and lithography.

The swimmer paintings came next. Elongated oval shapes that had appeared first in her final house painting, *Termino Avenue* (p. 145), became abstract swimmers in a series of more than twenty large pictures and also in her first public commission, a General Services Administration grant to execute a work for a federal courthouse in Atlanta. The new pictures had a dual format: enameled steel plates on one side, oil on canvas on the other. "I hadn't painted on canvas in years," she said, "so I decided I'd just try it." She took great pains to match the colors in the two media; the enamel-on-steel surface was brighter and more reflec-

tive, but she was able to make the contrasts work together in interesting ways. For the 160-foot-long lobby of the Atlanta courthouse, she proposed a series of nine paintings collectively entitled *Swimmers Atlanta* (pp. 90-93) and ranging in size from two feet to eighteen feet square. Bartlett's sense of geography is a little hazy. When she made the proposal, she thought Atlanta was on the ocean, or near it, and each of the nine paintings, for which she had made the preliminary drawings in watercolor, dealt with an aquatic subject — icebergs, whirlpools, eels, boats, and so forth — in a range of semiabstract (or semifigurative) styles. The GSA accepted them without argument. Bartlett finished the commission on schedule in 1977 and hurried back to her new living-and-working loft in SoHo, an immense space purchased with income from the house paintings and redesigned in a spare, art deco style. She was working at full tilt, finishing the swimmers series, painting three big new dual-format works (steel plates and canvas) with more realistic imagery than she had used before (*At the Lake, At the Lake, Morning,* and *At the Lake, Night,* pp. 57-59), and then immediately starting in on another series of even larger paintings — steel-plate paintings with canvas cutout swimmers glued to the surface—on the theme "at sea." Her work was in considerable demand by this time, and Bartlett was feeling the multiple pressures of success. What she needed, she thought, was some time to herself in a place far from New York. The apparently perfect solution presented itself in 1979, when she met Piers Paul Reid, the writer, at a dinner party in New York and he proposed that they trade living quarters for a year — his villa in Nice for her loft-apartment in SoHo. She agreed to the suggestion on the spot, sight unseen.

Her acute disappointment, when she moved into that dreary villa on the wrong side of town and far from the sea, at a time of year (December) when the Côte d'Azur is at its worst, has been much described. At first she felt distinctly frightened, alone in her damp, cold house and knowing barely a word of French. She used to practice shouting "au secours" in case of burglars, although there wasn't much to steal. It rained and rained. Her plan had been to do no art making during her year in France. She would travel, go to museums, and write a new book tentatively entitled *Day and Night.* (*The History of the Universe,* parts of which have appeared in several vanguard magazines, is still unpublished in its totality; a shortened version is scheduled to come

out in late 1985). She did do some traveling, to England and to Italy: Ravenna for the mosaics, Padua for the Giottos, Florence for Renaissance art, and Venice for late Renaissance painting, which she had never liked until then. Naturally she visited the nearby Fondation Maeght, in St. Paul de Vence, and the Matisse Chapel in Vence, which strongly impressed her. For some reason, though, she could get no writing done. And because she is "no good at just having fun," as she puts it, the lack of an absorbing activity began to weigh on her. Several projects were started and abandoned, and then one day she sat down with a pencil and paper at the dining-room table, looked out the window, and began to draw "the awful little garden with its leaky swimming pool and five dying cypress trees."

In the Garden (pp. 34-35), the series of nearly two hundred drawings, in ten different media, that grew out of this unpropitious beginning, has running through it a remarkable sense of self-discovery. Picasso talked of forcing himself to forget how to draw. Bartlett had decided to learn to draw — to get down on paper what she saw, that is, with her eyes and her extremely active mind. There had been no courses in this sort of drawing at Yale. Students who were accepted were expected to know how to do it, but in our era a surprising number of well-established contemporary artists have never learned. Bartlett had some help from her younger sister, Julie Losch, who came to stay with her for a few weeks in the villa. Julie had recently graduated from the Art Center College of Design, Pasadena, and was on her way to becoming a commercial artist. She knew about shading, perspective, and other conventions that Bartlett had never bothered with, and she could pass some of this on. One of the delights of *In the Garden* is the increasing skill with which the artist renders the banal scene — the moribund swimming pool with its kitschy statue of a small boy urinating, the background of dark, shaggy trees, the shrubs and the perennials in their unkempt beds. She shows it to us in every kind of light and shade (moonlight included), from every conceivable angle (sometimes we are looking down from a considerable height), and in countless variations of style, from virtual abstraction to meticulous realism. Many of the drawings were done in pairs, some with the more figurative one on the left and the more abstract one on the right. The "everything" that Bartlett usually aims for is here in full measure. Look at this absurd garden, she seems to

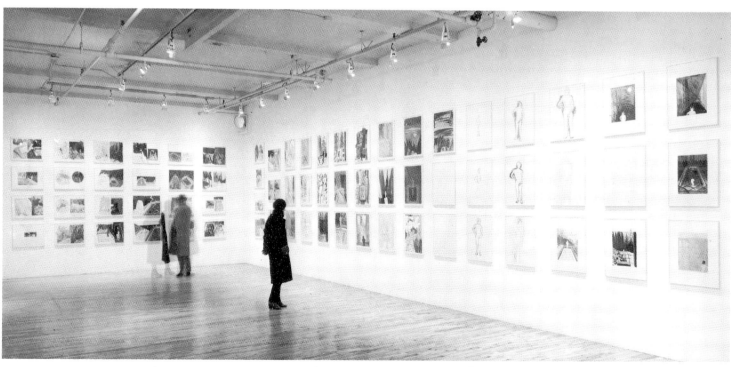

(opposite)
In the Garden drawings
Views of 1981 exhibition
Paula Cooper Gallery

In the Garden 64 1980
pencil on paper
26 x 19½
Collection Robert K. Hoffman

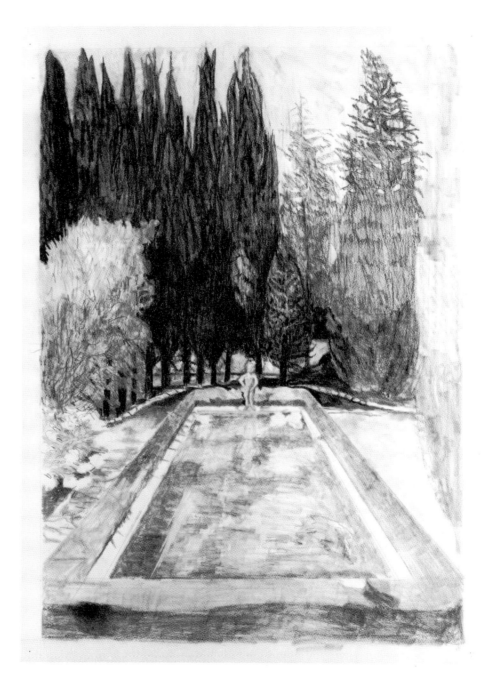

be saying — look at it long enough and hard enough, and you can find the world.

Bartlett spent fifteen months on the project. Some of the later drawings were done from photographs, after she returned to New York, and others were done from memory. Her godson posed for a group of figure studies in which the little statue comes to life. Each of the ten media — pencil, colored pencil, pen and ink, brush and ink, conté crayon, charcoal, watercolor, pastel, oil pastel, and gouache — is explored thoroughly and boldly, with particularly impressive results in pastel and in watercolor. When the complete series of 197 drawings was hung together for the first time, at Paula Cooper's in 1981, it had an even stronger narrative "pull" than *Rhapsody*. Critics commented on the "cinematic" effect of the shifting points of view and on the astonishing range of styles. An odd combination of qualities was visible throughout the series: spontaneity, bordering now and then on impatience, and at the same time a powerful analytical intelligence that stood back from the work in order to see where it was leading. The analytic side of her talent had always been there, causing some critics in the past to find her work cold and unfelt; here it was in perfect balance with her impulsive, risk-taking courtship of excess. The strongest narrative thread was Jennifer Bartlett's unflagging curiosity, her high-spirited willingness to let the act of drawing call the shots.

Since the enormous critical success of *In the Garden* Bartlett has been working harder than ever. Although she often says she hates commissions and will never undertake another, she has undertaken three major ones since *In the Garden*: the dining room of Charles and Doris Saatchi's house in London (pp. 115-119), for which she executed works in oil, charcoal, fresco, enamel, tempera, and collage; a huge steel-plate piece for the Institute for Scientific Information in Philadelphia (p. 105), a building designed by Robert Venturi; and a multipart work for the new international headquarters of the Volvo Corporation, in Sweden (pp. 130-136), which included several pieces of large, free-standing sculpture as well as paintings. The recent work has been increasingly figurative and involved with landscape, or, to be more accurate, with land-and-waterscape, since Bartlett's passion for lakes, streams, and the sea has not abated. Some of her admirers wonder whether in these fluent realist landscapes Bartlett may not be finding at last her own particular

style. Paula Cooper doubts this, and so does the artist. When I asked her about it, she said, "I certainly hope not."

The feminist movement had a significant effect on the New York art world in the 1970s. While Bartlett would hardly agree that full equality is at hand, the situation for women artists is certainly more open than it used to be, and a great deal more open than it is in Europe. In spite of this, the generation of American artists that came along after Bartlett's, the generation of Julian Schnabel, David Salle, Robert Longo, and others whose work began to attract public notice in the late 1970s and early 1980s, is dominated once again by men. It is too soon to tell whether the shift is temporary and accidental, or whether it reflects social or aesthetic considerations, or whether it represents a mix of both conditions. In the present climate of heavy-handed, macho, neo-expressionistic painting, however, Bartlett's inclusive, analytical approach may tend to make her work appear more "decorative" than it actually is. This issue does not trouble her. All painting is decorative to some degree, she feels; what it is in addition to that is what counts. She does not see why she should do without the decorative element, or any other element that appeals to her. There may be something of Long Beach in that attitude, but there is also a lot of New York.

Bartlett met Mathieu Carrière at a New York dinner party in 1980 and they were married in 1983. Carrière has been a highly successful actor in European films since he was thirteen (he is now in his mid-thirties), and because his work is in Europe, Bartlett now spends about half the year living in Paris, in a fairly grand apartment near the Luxembourg Gardens. She has told friends that she dislikes living in Paris. "Paris is so boring," she said last spring, just before going back to rejoin her husband. "After I'd been there for six months, last year, I realized that I'd hardly laughed once the whole time. I'm very frightened that being away from New York half the year may be bad for my work."

Elizabeth Murray reports that since Bartlett returned to Paris this time (summer, 1984), she has sounded, over the transatlantic telephone, enthusiastic about life over there. No doubt she will make something out of the place, just as she did out of the dingy garden in Nice. Paris may not be New York, but it is not entirely without interest for an artist. Paris, in fact, might turn out to be just the place for an ex-Long Beach cheerleader to lose and then find herself in a gigantic new work of art.

Jennifer Bartlett:
On Land and at Sea

Marge Goldwater

Jennifer Bartlett's artistic journey during the first decade and a half of her public career has taken both artist and viewer to a variety of sites around the globe. The series and individual titles of her work read like notes from a Baedeker: *Falcon Avenue, Seaside Walk, Dwight Street, Jarvis Street, Greene Street,* 1977, named after East and West Coast addresses of the artist; *At Sea, Japan,* 1980; *Up the Creek,* 1981-82; *To the Island,* 1982; and *In the Garden,* an ongoing series she began during a sojourn in the south of France in 1979. In the course of her travels Bartlett has explored issues in painting and pursued the possibilities of subject matter with a vigor and determination that would impress the most seasoned of travelers.

Moving from highly controlled abstraction to painterly realism, from two dimensions to occasional forays into three, Bartlett's work has changed considerably over the years. Although early paintings look radically different from her recent ones, the evolution of her work has been steady and logical, and fundamental attitudes have prevailed throughout. Gardens, lakes, and islands usually conjure up thoughts of recreation, but Bartlett's approach to making art has been anything but leisurely. She has a knack for turning her ideas into monumental homework assignments; these arrangements (or "self-commissions," as Roberta Smith refers to them) provide both a structure and an outlet for the obsessiveness and ambition that are such crucial aspects of Bartlett's work throughout her career. These two qualities are not ends in themselves for the artist but, rather, signposts of the all-important underlying

tensions: the polarities of control and passion and the intense desire to master — to master space, media, subject matter, and draftsmanship in a very conscious and deliberate manner. Bartlett has always worked in series, and in the course of each of them we see her wrestle with these tensions.

In 1968, three years after she received her MFA from Yale, Bartlett moved to New York City, where she has since maintained a studio. Early on, her work was very much task-oriented, in keeping with the basic tenets of process art, as it was then known, whose interest lay in the activity of creation rather than in the object itself. That year, 1968, Bartlett hit on the idea of painting on sixteen-gauge steel plates, coated with white enamel and overlaid with a light gray quarter-inch grid, fabricated to order. Their use was a logical outgrowth of drawings she had been doing on graph paper since her college days, and for eight years she worked on the plates exclusively. They were her trademark; they served her purposes nicely. They not only eliminated the need to build stretchers for canvases, they also made her works readily transportable. The plates may also have appealed to Bartlett because they were anti-art; after all, hadn't canvas always been the proper surface for a serious painter? For Bartlett, who had come of age at a moment when many thought painting had reached a dead end, the plates suited her conceptual and minimalist orientation; their use offered a way to circumvent painting conventions while working with pigment and to follow her strong analytic bent. The cool, gridded surface allowed her to translate any image or pattern into quantifiable daubs of paint.

Bartlett's work from this period has a distinct computer printout look. The paintings, composed of myriad colored dots of unmixed Testors enamel paints, each carefully placed within the grid, read like a modern day version of Georges Seurat's pointillist canvases. They are governed by rules of her own devising. For example, in *Binary Combinations*, 1971 (p. 38), Bartlett worked with six colors, alternating them in combination with one another on the left side and mixing them on the right side. The colors were mixed optically on the left and physically on the right. Her elaborate system for adding different colors in varying numbers in *Series VIII (Parabolas)* of the same year confounds its strict organizing principles with its romantic suggestion of a cosmic ocean (p. 41).

Georges Seurat
Port-en-Bessin　1888
oil on canvas
25½ x 32½
Collection The Minneapolis Institute
of Arts, William Hood Dunwoody Fund

(p. 38)
Binary Combinations　1971
baked enamel and silkscreen grid,
30 plates
64 x 88
Collection Cooper/Rosenwasser

Series VIII (Parabolas) 1971
baked enamel and silkscreen grid,
enamel on steel plates
36 plates
77 x 88
Collection Walker Art Center, Minneapolis.
Gift of the T.B. Walker Foundation

Bartlett exhibited a roomful of the abstract enamel plates in 1972 at the Reese Palley Gallery in New York (p. 16). The installation proceeded logically, beginning with a series of single-plate works, followed by a series of two-plate works, then a series of three-plate works, and so forth. The overall effect, however, was dizzying. It became clear that there was a madness to Bartlett's method. At this early stage in the artist's development the opposing forces of system and intuition were already manifest. The will to master was present, too, as the artist boldly proceeded to conquer the wall space of the entire gallery in uninterrupted fashion with her works.

Her work from the early seventies has strong affinities with Sol LeWitt's systems-oriented art. But, LeWitt's program is generally more apparent visually, and its premise is reinforced with titles such as *Lines from the Center, the Corners and the Sides*, 1969. Whatever the initial impulse, Bartlett's works are ultimately governed by an idiosyncratic agenda rather than by mathematical truths. Where she considers the theme of infinity, for example, in the monumental *Drawing and Painting*, 1974 (p. 8) — a twelve-foot ten-inch tall, triangularly shaped work — she perches the painting precariously on one plate like a giant flamingo. By contrast, LeWitt's meditations on infinity are conveyed with highly regular, overall compositions.

Intended to be read either up and down or across, *Drawing and Painting* implicitly calls into question the nature of the two activities in its title by examining what constitutes a line versus a painted plane and what happens when that plane acquires color. *Squaring*, 1973-74, (p. 43), a slightly earlier work, shares a similarly investigatory attitude, visually demonstrating the mathematical operation of squaring. The result is a rather lopsided structure. The first plate has 2 dots, the second plate has 4, and so on, until the work reaches the final function, 256 squared, whose 65,536 dots occupy thirty-three plates.

Her work was abstract during this period with one important exception. Bartlett says that at the time, "Artists' dedication [to abstraction] took a very aggressive form, like joining a religious movement."[1] As though on a dare, she decided to introduce an image of a house, first in a small plate piece in 1969 which was incorporated into the larger *House Piece* (p. 44) of 1970, where it comes complete with duck pond and picket fence and interior views. She subjected the house, an image

Sol LeWitt
*Lines from the Center
of the Wall, Four Corners, and
Four Sides to Points on a Grid* 1976
wax crayon on black-painted wall
Courtesy John Weber Gallery

Squaring 1973-74
baked enamel and silkscreen grid,
enamel on steel plates
33 plates
77 x 116
Collection the artist

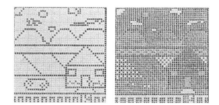

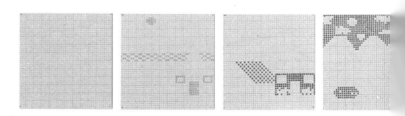

she describes as "banal yet poignant," to the same systematic manipulation that she used with her abstract pieces. In its transformation this model middle-class dwelling, doubtless the original home of Dick and Jane, suffers a slew of worrisome fates as its elements drop out or are magnified and as plates shift from color to black and white, until finally, at the end of the story, the entire house is set on its side. Composed of sixty-one plates in all, *House Piece* is laid out in four horizontal rows with pauses in between its movements as though to emphasize the work's symphonic structure, a reference that becomes so strong in her later work, *Rhapsody*, that the literal rest stops — large spaces left between plates — were no longer necessary.

The tightly controlled systems look of her work in the early seventies, which represents the artist's intellect more than it betrays her hand, reflects the minimalist aesthetic that then prevailed. The painting is devoid of the emotionalism of Abstract Expressionism, the dominant painting style that preceded Minimalism. The artist herself has suggested that her writing at the time (she was working on an autobiographical novel entitled *The History of the Universe*) was her major outlet for highly charged feelings.

Bartlett worked in series and relied on the structured situations of works such as *Squaring* and *Series XV (Intersections)*, 1971, a linear piece showing the number of different ways two lines can intersect, "to alleviate the pressure of creating a 'masterpiece.'" Paradoxically, that very strategy brought forth *Rhapsody* (pp. 22-27), her 153-foot-long triumph of 1975-76. The painting, composed of 988 of her steel plates, could cover the walls of her studio three times over.

When this monumental work was exhibited two and a half years later in the Whitney Museum of American Art's *New Image Painting* show, the artist characterized her work as follows:

Rhapsody was conceived of as a painting that was like a conversation in the sense that you start explaining one thing and then drift off into another subject to explain by analogy, and then come back again, and include as much as you can so that you are able to follow those elements through separately or look at them in total. I wanted to explore some of the basic elements of paintings — break things down into various categories. I decided that you can have lines in a painting, and they can be of four sorts — horizontal, vertical, curved, and diagonal — and they can be of different colors and different lengths. There are three possible ways of making a mark on a two-dimensional surface — dotted, freehand, or measured. There are three possible shapes — a square, a triangle, and a circle; and these can be in three sizes — large, medium, or small — which, of course, is relative to any given surface.

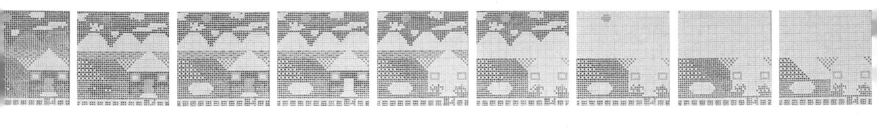

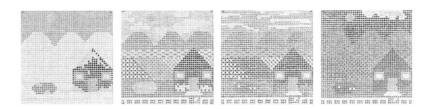

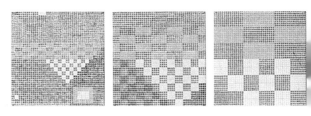

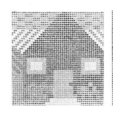

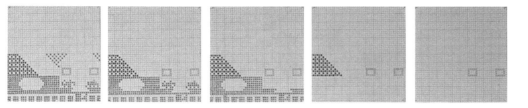

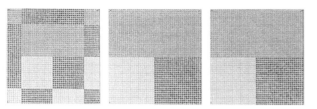

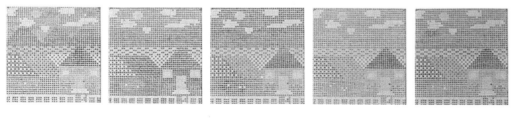

(gatefold)
House Piece 1970
baked enamel and silkscreen grid,
enamel on steel plates
61 plates
90 x 259
Schloss Collection

There also exists a whole area of imagination and intuition — the choice of imagery — and I decided to select the first four things that came to my mind: house, tree, mountain, and ocean. I then used these four images and did a movement or section for each of them. Realizing that everything is colored in a certain way, I decided that color would run like a heartbeat through the entire piece — like a pulse — so that each movement or section had its own color problems. I determined that you could put color down in three ways — next to each other, mixed, or layered — and devised a different color problem for each section.[2]

Bartlett's attempt to analyze everything by breaking it down into its components and examining its various permutations informs this work as much as it has her previous work, in her attempts, for example, to show how two colors can combine (*Binary Combinations*, 1971) or how two lines can intersect (*Intersections*, 1971). In *Rhapsody* we find to an unprecedented degree the polarities of method and madness, reason and passion. It is as though Bartlett becomes the mad scientist, trying to discover the mysteries of painting under the objective lens of a microscope. All aspects of painting, from line to color to shape, are enlarged sequentially, the better for the artist and us to inspect. At the same time, a passionate commitment to the act of painting itself, as registered by *Rhapsody*'s enormous scale, offsets the scientific and didactic approach. The elaborate structure seems created to rein in what might otherwise be unbridled, perhaps untenable, passion and ambition.[3]

As the painting unfolds in its conversational way, Bartlett tries on styles as a little girl tries on her mother's clothes, moving from traditional realism to Abstract Expressionism to Minimalism to Conceptualism, with stops at points in between, all the while fueled by the desire not only to comprehend but to master the possibilities of painting. She carries on a dialogue with the entire history of modern painting, attempting to summarize her own ideas as well as her understanding of the nineteenth- and twentieth-century context in which they emerge. As she moves from one mode of expression to the next, her intention appears less a discourse on style than an extraordinary effort to test herself, to see how well she can manipulate the images in an interesting manner and conquer an enormous space.

If, in fact, the selection of subject matter for *Rhapsody* (house, tree, mountain, ocean) was as arbitrary as Bartlett claims — "the first four images that came to mind" — seldom have the powers of free association borne such fruit; indeed, three of these images, the house, ocean,

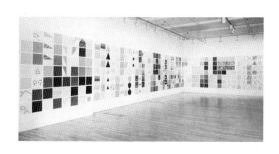

Rhapsody 1975-76
View of 1976 exhibition
Paula Cooper Gallery

and tree, remained recurring motifs for several years. The ocean has deep personal significance for Bartlett, who grew up in Long Beach, California, on the sea, and over the years, she has produced several independent series of works based on this motif. Water has proved to be the fertile territory for Bartlett that landscape is so often found to be for other artists, and in her recent *In the Garden* series she focuses on trees.

Reintroducing representational elements for the first time in several years, Bartlett nevertheless maintains her schematic and analytic approach. Without minimizing the suggestive power of her archetypal images, we should note that *Rhapsody* develops and then dissects them in somewhat deadpan fashion throughout. One's engagement with the work comes less from the specific depictions of themes than from the synergistic effect of piecing together a long series of variables in an exuberantly rhythmic pattern.

This stunning, environmentally scaled work summarizes Bartlett's concerns at the time and serves as a table of contents for the paintings that follow. It contains most of her themes and all her signature devices, both past and future, among them the comparative presentation of multiple styles and points of view. An artist generally strives in each new painting to reveal everything that he or she has learned to date. With *Rhapsody* Bartlett pushes this ambition much further, attempting to recapitulate as well large portions of art history.

After *Rhapsody,* the artist originally intended to do two paintings on each of that work's motifs. She began this self-imposed assignment with the house image; by the time she moved on to the ocean motif, she had completed thirteen major paintings of houses and numerous smaller versions. It was then the mid-seventies, and the house had become a familiar image in contemporary art, if more frequently pursued by sculptors than by painters. Artists like Jackie Ferrara and Siah Armajani explored its architectural aspects, while Charles Simonds and others demonstrated a concern with sociological issues latent in the image. In autobiographical and emotional attitudes, however, Bartlett's houses had much more in common with those of sculptor Joel Shapiro. For Bartlett, as for Shapiro, the house functions almost as an alter ego, a perfect metaphor for registering the shifts in mood and the different phases of her life. It is not surprising that she became engrossed in such a universally potent theme. It would seem an especially persuasive symbol

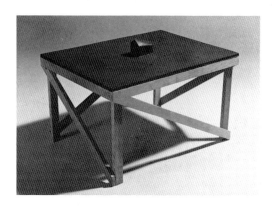

Joel Shapiro
Untitled 1975
cast iron, wooden base
20 x 22 x 29½
Collection Walker Art Center, Minneapolis.
Purchased with the aid of funds from the
National Endowment for the Arts, Mr. and
Mrs. Edmond R. Ruben, Mr. and Mrs. Julius
E. Davis, Suzanne Walker and Thomas Gilmore

from the artist's feminine perspective since women have for so long defined themselves through their household accomplishments and family involvements.

The biographical and autobiographical references in the 1977 house series are reinforced by their titles, all addresses of family and friends. *Falcon Avenue . . .* (p. 52) is a five-part work whose title cites the places where she lived "at birth, upbringing, marriage, graduate education and divorce and confusion."[4] Typical of her systematic approach, each of the first four sections is painted in a different way; the fifth consists of four units from each of the previous segments. In this final portion, however, the neatly dotted plates repeated from the far left are now splattered with paint, indicating the impingement of later, more turbulent experiences on the innocence of childhood.

In the next painting, *5725 East Ocean Blvd.*, another of Bartlett's Long Beach addresses, the artist describes a more limited time frame — day to night — relying on color to convey the passage of time. She uses a compare-and-contrast format: flatly painted versions of the house on the left side and, in the large, central section and the others to the right, houses whose active brushstrokes blur the forms. The grandly scaled house in the central section suggests perhaps the way in which certain places loom larger in one's mind or memory at various times. Of paramount concern is the effect of changes in light on the subject, as it was for Monet in his haystack paintings, whose hutlike shapes are surely evoked by Bartlett's houses. This reference to the French master is part of her ongoing dialogue with Impressionism, an involvement that must have been at least partly responsible for her decision to spend several months in the south of France in 1979-80. (Indeed, now that she spends half of her time in Paris, it will be interesting to see how this identification with French painting ripens in her work.)

The flat format of the house gives way to a perspectival view for the first time in the brown, gray, black, and white *123 E. 19th Street* (p. 143) and then *Graceland Mansion* (p. 31). Both five-part paintings indicate the passage of time by the way in which the shadow is cast. Bartlett, ever the diligent scientist, actually made a little cardboard model of the house and brought it outside at noon to trace the shadow. She then put a light bulb over it, and when the shadow matched up with the drawing, she moved the light bulb in an arc to get the correct

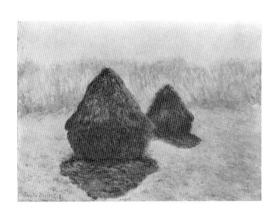

Claude Monet
Haystacks in Snow 1891
oil on canvas
25¾ x 36¼
Collection The Metropolitan Museum of Art, Bequest of Mrs. H.O. Havemeyer, 1929, The H.O. Havemeyer Collection

Falcon Avenue, Seaside Walk,
Dwight Street, Jarvis Street,
Greene Street 1976
baked enamel and silkscreen grid,
enamel on steel plates
80 plates
51 x 259
Collection Whitney Museum
of American Art
Gift of the Louis and Bessie Adler
Foundation, Inc., Seymour M. Klein,
President, and the National Endowment
for the Arts.

392 *Broadway* 1977
baked enamel and silkscreen grid,
enamel on steel plates
72 x 259 overall
Collection Edward R. Downe, Jr.

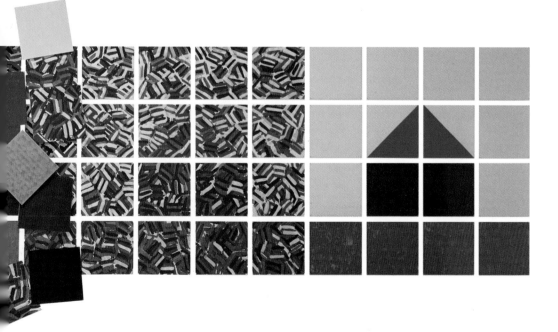

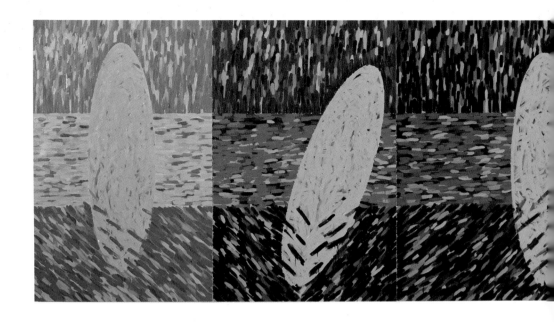

shadows at different times of day. In the paintings, however, she complicates matters by rotating the house a quarter turn in each section, thereby sabotaging her scientific inclinations once again. As Richard Field observes of her print *Graceland Mansions,* 1978-79, based on the painting, "Bartlett offers the viewer the consolation of order at the same time that she prohibits him/her from anchoring his/her mental focus to any one system of objective observation or picture making."[5]

While Monet's haystacks bespeak serenity and a surrender to nature, Bartlett's houses suggest the opposite. Most of them or their environs are in a state of flux, of anxious transition. In *392 Broadway,* (pp. 52-53), named for a friend at that address in the midst of a divorce, for example, the plates in the middle section spill beyond the grid in an active state of disarray, and John Russell's description of *Graceland Mansion* — "a blocklike house holds fast to its identity while time and tumult revolve around it"[6] — seems especially apt.

With the introduction of a curious lozenge form that looks like a flying saucer that has landed in one's home, *Termino Avenue* (p. 145) is both the last of the 1977 house paintings and a bridge to the swimmer series that follows. In this regard a transitional work, it is not surprising

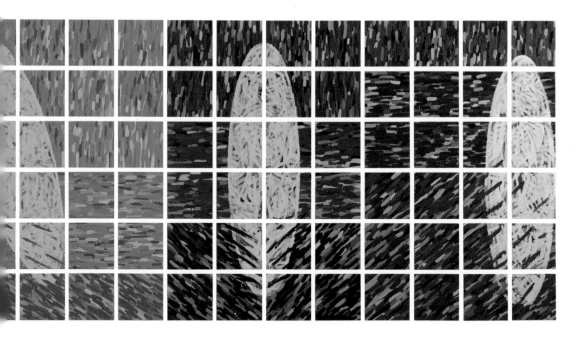

to learn that it commemorates a significant event in the artist's life: her father had died in a hospital on Termino Avenue in Long Beach two years before. When Bartlett removes the ellipse from the security of the home and casts it into the sea in her next series, she intends the form to be read as a swimmer.

Returning to the ocean motif, Bartlett tackles the second phase of her post-*Rhapsody* homework assignment. Her approach to this theme reveals many familiar maneuvers: the concern with the passage of time is conflated with shifts in mood throughout the several series in which the swimmers appear. As the swimmers are subjected to a battery of endurance tests in much the same way the houses were challenged (one of Bartlett's siblings, in fact, was an Olympic swimmer), the artist's analytic intelligence continues to prevail, but the series also opens a period of experimentation and exciting development. Perhaps it is Bartlett's return to canvas for the first time since she began working on the steel plates nearly ten years earlier that foments the change.

Swimmers, 1978, and *Swimmers at Dawn, Noon and Dusk*, 1978 (p. 54), the first two paintings in the new series, are both half canvas, half plates. Another mind would surely have made the boundaries of the

55

canvas match up with the boundaries of the plate section in these comparative works; one *wants* the borders to line up. But Bartlett is committed to a fairness doctrine that will not permit such inequities, however subtle. In her many works that center on comparisons (e.g., *27 Howard Street/Day and Night,* 1977 [p. 144], and *Sad and Happy Tidal Wave,* 1978 [p. 146]), she always presents us with both sides of the argument. With the swimmers, therefore, the canvas must occupy only as much surface as the plates, even if at first glance the allotment *feels* like a mistake.

As we follow the life and hard times of the lozenge lost at night (*Swimmer Lost at Night* [for Tom Hess], 1978 [p. 147]), swept up in tidal waves (*Sad and Happy Tidal Wave, Tidal Wave II,* 1978), in a storm (*Swimmer in the Storm,* 1979), and then in a variety of encounters with the elements, ranging from icebergs to whirlpools in *Swimmers Atlanta,* 1979 (pp. 90-93), a nine-part installation in the Federal Building in Atlanta, another tale, every bit as compelling, begins to emerge. In the course of these hybrid paintings, all of them part canvas, part plate, the power of Bartlett's brushstroke finally overwhelms the force of her elaborate organizing principles. In *Rhapsody* she orchestrates everything, to the degree that in certain sections color is carefully dispensed one brushload of paint per square inch. In *Swimmers at Dawn . . .* we have more regulated brushstrokes: the painting is divided into thirds, and, reading top to bottom, the brushstrokes are vertical, horizontal, and then diagonal. But the use of canvas in the newer works increases the potential for expressive painting. The limitations of the gridded plate structure, whose surface is interrupted every twelve inches in every direction, are not present in the canvas portions. In *Swimmers Atlanta,* the final group of paintings in the first swimmers series, the tide brings forth a painter who demonstrates not only the stamina of the marathon swimmer but, with her liberated brushstroke, the same sense of confidence, exultation, and exhilaration that comes with athletic feats.

Bartlett draws us into much deeper space when she takes us to the more secluded and contained lake site in her next cycle, the three *At the Lake* paintings (pp. 57-59). The biomorphic form of the lake, with its numerous flesh-toned ovoids swimming about, suggests a womb. Despite the abstraction of the swimmer shapes and the spatial ambiguity, these paintings provide a far more literal depiction of a scene than

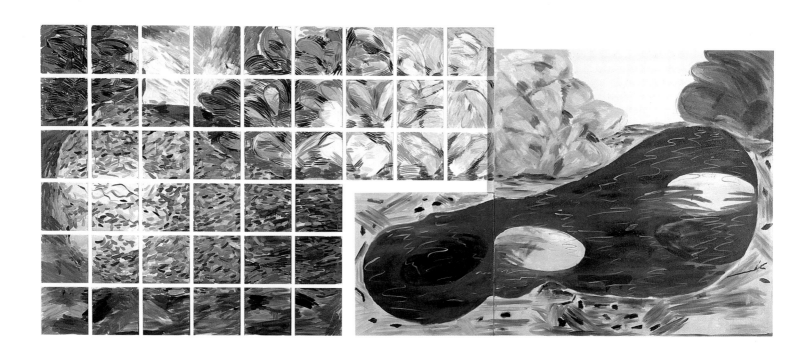

At the Lake 1979
baked enamel and silkscreen grid,
enamel on steel plates; oil on canvas
45 plates, 2 canvases
77 x 188 overall
Saatchi Collection, London

At the Lake, Night 1979
oil on canvas; baked enamel and
silkscreen grid, enamel on steel plates
45 plates, 2 canvases
77 x 188 overall
Speyer Family Collection

Bartlett has attempted previously. Once again concerned with the passage of time, she represents in each work one part of the day — and one mood — instead of showing the extended time sequences of the house paintings. More eccentrically configured than ever before, these works are also composed of plates and canvas sections, mirror images but for the curious interlocking center sections of plate and canvas that intrude on each other in a maddening way, making both images forever incomplete. The drama in these three paintings comes not from the swimmers engaged in heroic battle with the elements but from the viewer's attempt to become oriented. It is Bartlett's version of trouble in Paradise as she leaves us to ponder the mysteries of nature and of painting in this idyllic but slightly awry setting.

The artist continues to pursue the swimmer motif in the paintings that follow the lake series, including another set of three paintings, *Swimmers and Rafts*, whose formats become increasingly eccentric. She experiments with triangular, elliptical, and diamond-shaped canvases, each time combining the canvas with plates arranged in similarly unusual configurations. In the tripartite composition *Swimmers and Rafts, Ellipse* (pp. 150-151) the central canvas assumes the elliptical form of the swimmer itself, and the rectangular plate formations that flank the canvas on each side refer to rafts. The *Swimmers and Rafts* paintings retreat from literalism, dominated as they are by the rafts, whose big, flat, brown forms function like minimalist paintings within the works' overall structures.

At Sea, 1979 (p. 61), is the most abstract and painterly work in this series. The short, broad, active brushstrokes and luscious color recall Monet; the overall composition and subject matter make direct reference to that artist's Water Lilies. Unlike all the other swimmer paintings, which are half plate, half canvas, this work has two small canvas lozenges that overlap the grid. While the dimensions of *At Sea* are variable — the fact that one is free to arrange the plates to suit the wall space is an eccentricity in itself and perhaps a throwback to the artist's earlier, more conceptually oriented period — the painting does not seem as tentative or experimental as do others from this period. Paradoxically, although it lacks identifiable features that might make the viewer feel more secure, a little less at sea, such as the shoreline in the lake series or the rafts that followed, this painting demonstrates tremendous confidence and facility. Determined as ever to utilize every square inch of

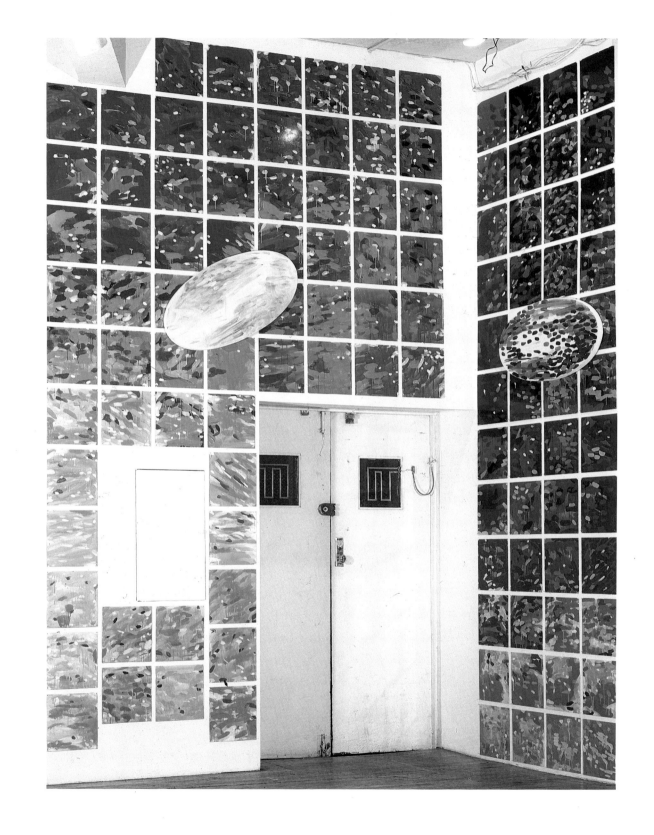

available space, Bartlett originally installed the painting floor to ceiling at the Paula Cooper Gallery in 1979 in an awkward area over the entrance and around a fuse box. The painting vocabulary developed in this composition reappears in the later, environmentally scaled *At Sea, Japan,* 1980. Here Bartlett broadens her palette beyond the blue-gray range of *At Sea* to include passages that progress linearly, like those in *Rhapsody,* expanding with great lyricism on the day-to-night theme.

If, as Bartlett acknowledges, she was feeling at sea herself for a while it was not long before she launched herself on another major project. She had rented a villa in Nice for the winter of 1979-80, and, as the now legendary episode has it, the house turned out to be dreadful and the weather worse. But the garden beyond the dining room, in reality a sorry-looking affair consisting of a reflecting pool with a mawkish statue of a young boy and some trees, proved as much an inspiration for her as the lush gardens at Giverny had for Monet. Bartlett embarked on a series of two hundred drawings that provides us with an experience as rewarding and life affirming as the activity of gardening itself.

Characteristically, Bartlett takes a vigorous approach to a languorous scene. Like *Rhapsody,* the *In the Garden* drawings (pp. 34-35) are organized by section and executed according to a strict set of guiding principles. She uses no fewer than ten different media and, in the ten different sections that evolved, the paper size remains the same but the format varies from a double square to a single rectangle to an irregular polygon image to all-black drawings with a figurative image on the left side and an abstract image on the right side. She worked from life, from photographs, and from memory. As she transforms the garden into one marvelous vision after another, we sense an artist facing up to a series of challenges just as the swimmer — a surrogate for the artist — did in earlier works.

This body of drawings was shown twice as an ensemble, in New York and in Los Angeles in 1981. It bears a strong relation to *Rhapsody,* Bartlett's earlier tour de force. Both works are composed of numerous discrete elements, roughly the same size, whose sum is greater than the parts and whose systematic structure is transcended by the passion such a monumental enterprise represents. The drawings show shifts in scale but not in ambition. As Bartlett presents every conceivable view of the garden in an unending parade of styles, we see Matisse, Picasso,

Feininger, Delaunay, and others, just as we are marched by a similar parade of elders in *Rhapsody*. Above all, of course, we see Bartlett comparing herself with the masters, just as she contrasts abstract imagery with figuration, large scale with small scale, painterliness with linearity, gouache with pastel, and color with black and white. It is a mistake to interpret the rapid-fire stylistic changes as shallowness, as the inability to commit oneself said to be symptomatic of the 1980s. Rather, we are witness to a mind determined to analyze, understand, and thoroughly master a situation. In these drawings, her preoccupation with the mastery of physical space, critical to the triumph of *Rhapsody*, gives way to ardent concerns about mastering not only her subject but also the fundamentals of drawing and of various media. As Bartlett develops the series, she seduces us by making us party to her learning process, so that we, too, feel exultant about the results. She assigns herself the task of taking a dreary scene and transforming it into two hundred different visions, and in so doing, she affirms the powers of an artist. In the end, as Richard Field suggests, "Bartlett somehow manages to prove the endless variety of human expression and interpretation."[7]

Bartlett completed the drawing project on her return to the United States and then worked on two commissions based on the garden theme, one for the Institute for Scientific Information in Philadelphia (p. 105) and one for the dining room of a private home in London (pp. 116-119). The very successful, nine-piece London work pointed the way to a series of large multimedia works that continue to engage the artist. These environmentally scaled ensembles must be seen as a logical development of a space-conquering impulse that began with the artist's first installation at the Reese Palley Gallery in 1972.

Up the Creek, 1981-82 (pp. 121-123), a title that, like *At Sea*, suggests a period of quandary, is the first in a projected series of five installations. The work depicts a woodland scene in upstate New York that Bartlett photographed when visiting friends there. *To the Island*, 1981-82 (pp. 125-127), with its images of palm trees, seashells, and a bright blue sea, gives us ten views of a tropical island paradise from ten different perspectives. For both projects, Bartlett selected ten of her photographs as the basis of each work's parts. She worked with the same materials as she had for the London dining room commission: oil on mirror, oil on canvas, casein on freestanding plaster wall, pastel,

In the Garden 200 1982
oil on canvas
108 x 108
Collection Edward R. Downe, Jr.

26 Rue Vavin 1983
oil on 2 canvases
84 x 144
Courtesy Paula Cooper Gallery

87 Boulevard Raspail 1983
oil on 2 canvases
84 x 120
Courtesy Paula Cooper Gallery

charcoal, colored pencil, paper collage, enamel on glass, enamel on plates, and enamel for the folding screen she incorporated into each installation.

Noting the different styles of the various elements — from abstract, Matissean collage to traditional realism in charcoal and pastel and from two-dimensional painting on canvas to three-dimensional objects — a few critics have commented that the installation of *Up the Creek* and *To the Island* looks almost like a group show. In fact, it is all pure Bartlett. Characteristically ambitious, she once again surveys many artistic modes of representation, referring not only to masters like Cezanne, from whom she appropriates a bather for one of the oil-on-canvas segments in *Up the Creek*, but also to contemporary painters, among them Alex Katz. Once again she shows an intense commitment to examining a situation from every angle and, in investigating the influence of media on subject matter, brings an extraordinary amount of energy to sites generally associated with leisure activities. While *Up the Creek* and *To the Island* are inherently more problematic than their precursor, the London commission, which was unified by the nine dining room walls that acted as ready-made supports, it is also typical of Bartlett's singlemindedness that she has persisted in trying to develop to a successful conclusion the ideas first explored in these works. As she asserts, "*Up the Creek* and *To the Island* probably have as much wrong with them as anything I've done, but they are still, for me, among the most interesting things I've done."

In 1982 Bartlett completed a number of large garden paintings — including five based on drawings from the *In the Garden* series[8] and two, *26 Rue Vavin* and *87 Boulevard Raspail*, that were never exhibited — whose overall compositions seemed to relate most to the glass segment of *To the Island*. But it was not until the following year that she made a clear response to some of the more unresolved aspects of *Up the Creek* and *To the Island*. Temporarily abandoning her typical multimedia format and encyclopedic range of styles, the artist embarked on still another series of garden paintings, which reveal her powers as a painter in new ways. Conservative and courageous at the same time, they demonstrate a focus and commitment, a willingness to live solely by her wits as a painter, that we have not seen before. What may at first look like a retreat becomes an exciting step forward.

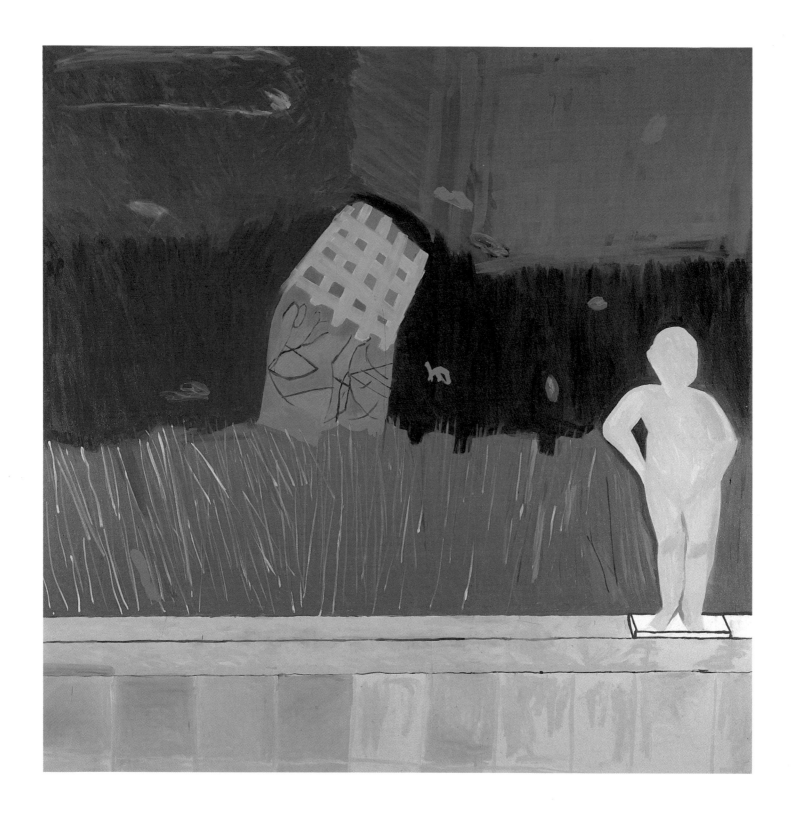

The new works, straightforward oil-on-canvas paintings composed of two to five panels each, do not derive their effect from complicated conceptual underpinnings or from changes in material and style. The emphasis has switched to narrative concerns, almost as though Bartlett is giving expression to her ambition as a writer. The new paintings are based on photographs rather than drawings and present sequential imagery rather than radical shifts in points of view. As a result, they have a distinctly cinematic character. Several of the photographs used were taken at night with a flash, lending some of the paintings an unearthly cast suggestive of detective novels. In these works an invisible presence seems to be manipulating things from behind the scene. The closest we get to a living presence are the shattered porcelain animals in the middle of the road in *Dog and Cat,* 1983 (p. 67), and the statue in *Boy,* 1983 (p. 6). An eerie calm prevails, exposing a side of the artist's personality we have not seen before. Bartlett observes, "Working on these paintings I realized that my dark side, which I thought would be excessive and devilish, turned out to be very dry and perverse, arid, cool and withdrawn, tight rather than expressionistic." In returning to the garden in Nice, Bartlett conveys an experience like that of a visit to one's old neighborhood, where everything looks familiar but appears to have shifted two inches to the right.

Several of the new paintings are based on long sequences Bartlett discovered among the photographs she had originally taken for the garden drawings. Beginning with *Wind,* 1983 (p. 68), the largest of these works, she presents consecutive views in each panel. *House,* 1983 (p. 73), the most eccentric of these paintings, returns us to a familiar subject but focuses on external narrative matters rather than autobiographical concerns. For the first time Bartlett gives us a glimpse of the house itself, the raison d'être for the garden that preoccupied her for so long. The villa is shielded by surrounding trees, shrouded in mystery. The reference to detective stories is here inescapable. Is there a murderer lurking in the bushes, waiting for darkness to fall, in the right-hand panel? Has he, by nightfall, gained entrance to the house? Curiously, the story unfolds from right to left, and, paradoxically, the nighttime segment is easier to read.

The pool takes on its strongest metaphorical significance as a container for feelings, as a stage for the drama of life, in the 1983 three-panel work by that title (p. 74). There is still an acute sense of mystery,

Dog and Cat 1983
oil on 2 canvases
120 x 84
Courtesy Paula Cooper Gallery

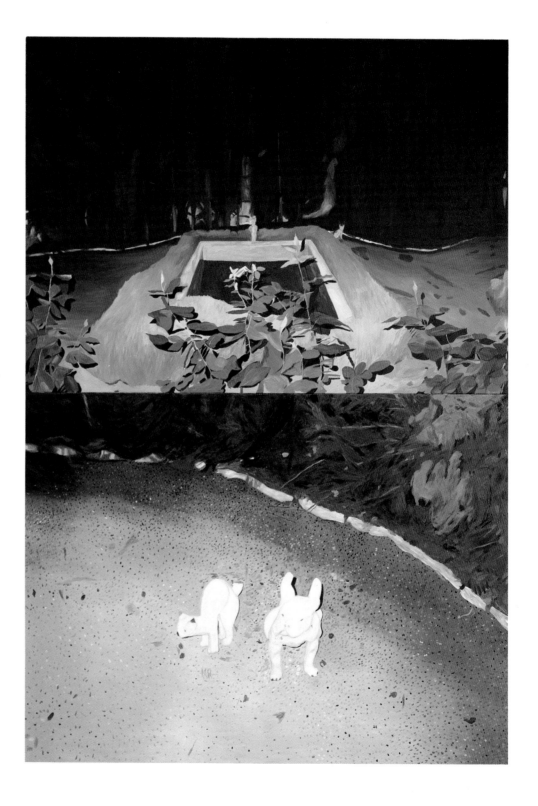

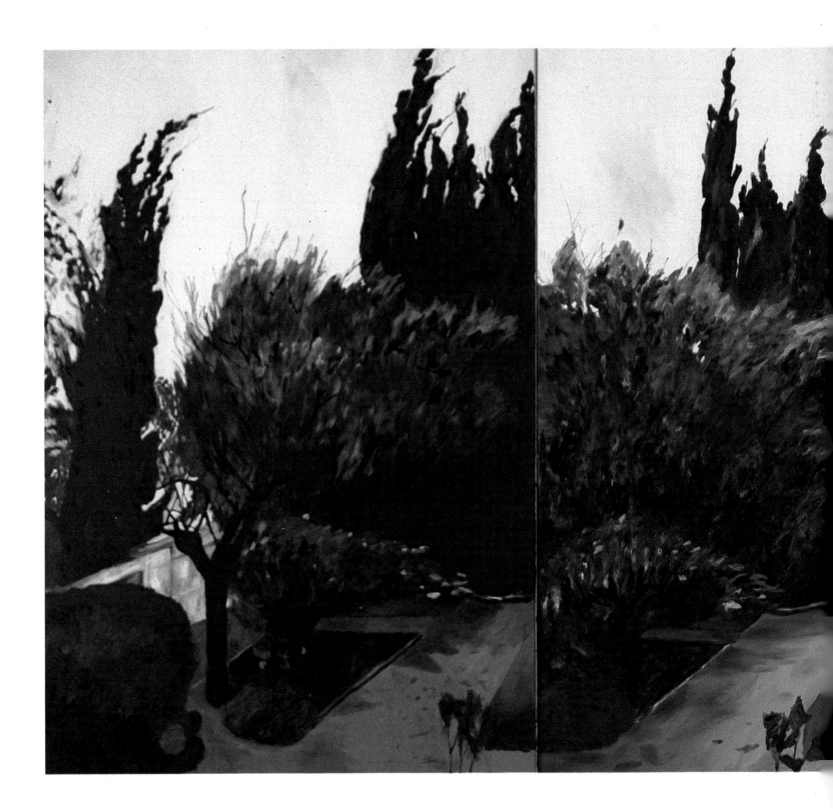

wrought by what might be blood in the pool and by the unexplained rise in the water level. On the other hand, we get to the bottom of things in *Pool* in a way we never did at the lake or at sea, where we were shown vast expanses but not the same degree of depth, either physical or emotional. The pool is lined with the familiar grid, though now the tiles are painted, not real, and the painterly brushstrokes overlaid on the grid have replaced the careful dots or short, regimented strokes of prior years.

The 1983 paintings have a seriousness about them that seems to say, "These are the real thing." But there are indications of other new directions in two commissions that occupied her subsequently — *Atlantic and Pacific, AT&T*, 1984 (pp. 128-129), composed of plates on one wall and a canvas of equal size on the opposite wall, and her most ambitious installation work to date (untitled) at the Volvo headquarters, Göteborg, Sweden, 1984 (pp. 130-136), which involves more three-dimensional elements than ever before. As successful and "true" Bartlett as the multipanel garden paintings are, she is too much of an adventurer and possesses a streak too perverse to settle down into one mode. When asked recently what avenues she intended to pursue in the future, she replied she would like to do more paintings like those in her last show, more three-dimensional works, some multimedia installations that perhaps utilize sound, as well as works that lean more toward abstraction. In other words, she has every intention of continuing her pursuits all over the globe, as it were. Undoubtedly we shall benefit from her wanderlust.

In an age of angst, Bartlett's fondness for things pretty makes critics nervous. True, she surveys the dark and mysterious, and demonstrates a keen ability to invest the mundane with meaning and variety. At the same time, she is never one to shy away from the traditionally beautiful and luxurious, an inclination that contrasts with both the industriousness of her approach and the prevailing taste for the expressionistic and the ugly in painting today. Faithful to early efforts in Conceptualism, her art continues to be concerned with learning and experimentation, with the process of mastery rather than perfection itself. It is almost in spite of herself that her recent paintings and drawings, in particular, have such an accomplished look. She is an artist who is distinguished for the monumental tasks she assigns herself, the enormous risks she glee-

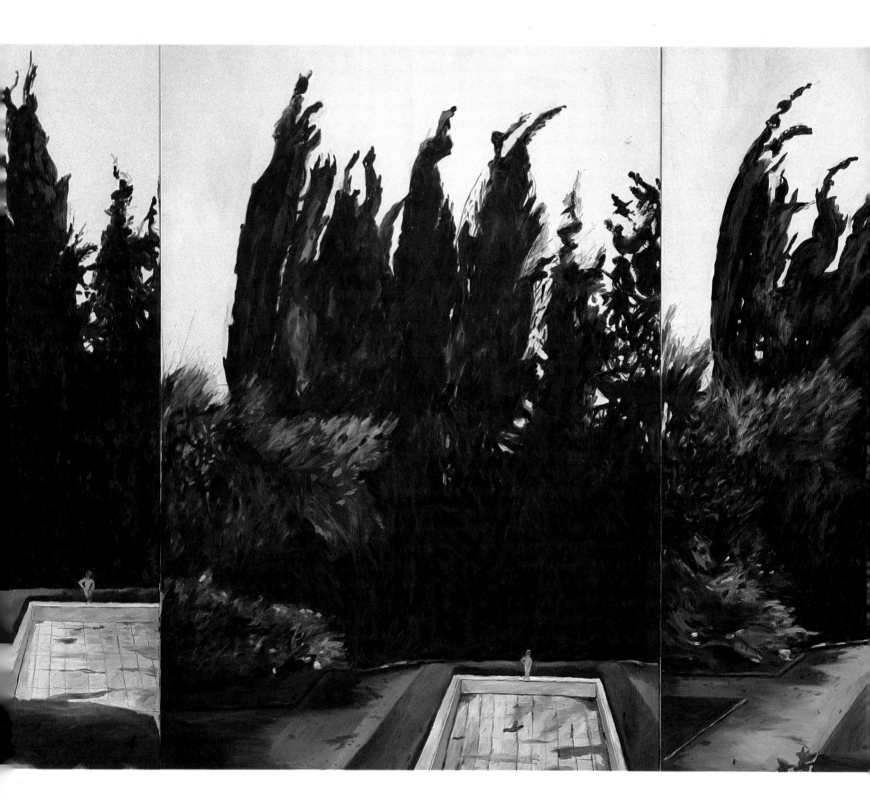

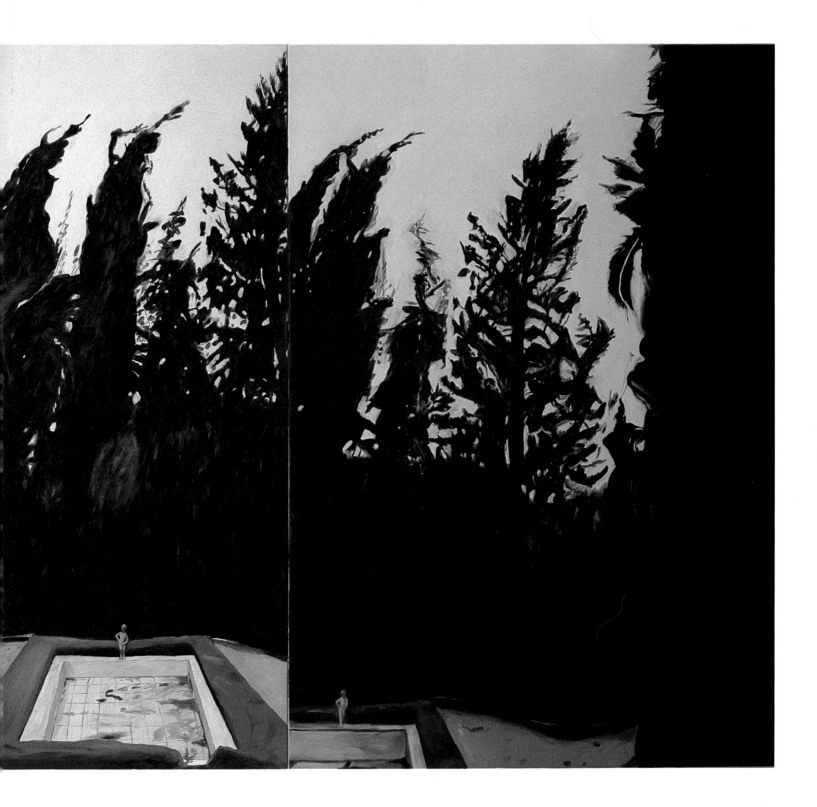

Wind 1983
oil on 5 canvases
84 x 300
Courtesy Equitable Life Assurance
Society of the United States

House　1983
oil on 2 canvases
72 x 120
Collection Broida Foundation

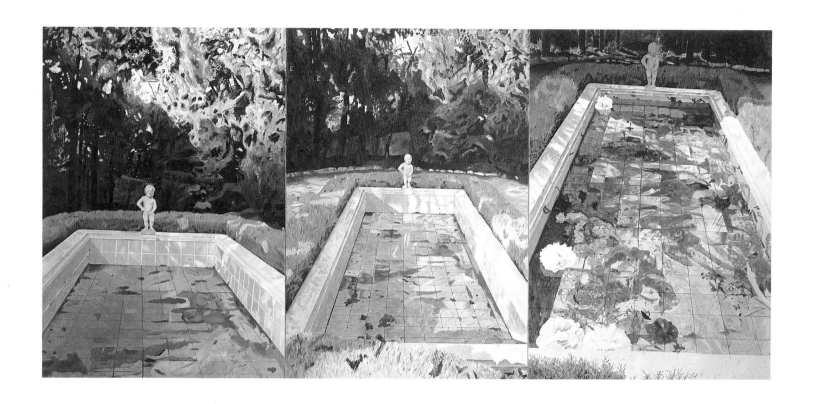

Pool 1983
oil on 3 canvases
84 x 180
Collection Mr. and Mrs. Aron B. Katz

fully undertakes, and the quality and originality of her responses. As her newest work, a series of paintings, pastels, and sculptures demonstrates, once again she is completely uninhibited about what she is willing to try, just as she continues to try to control herself with all sorts of rules and regulations about the project's execution. If at moments it appears a liability, over time her fearlessness has proved her greatest strength.

Notes

1. Quotations are taken from the author's tape-recorded conversations with the artist in 1983 and 1984.

2. Jennifer Bartlett, as quoted in Richard Marshall, *New Image Painting* (New York: Whitney Museum of American Art), 1982, p. 20.

3. Bartlett recently discovered a "flaw" in *Rhapsody*. In the introductory section she presents the circle painted freehand, dotted, and measured in small, medium, and large sizes but forgot to do the same in the subsequent sections with the square and triangle. The work's success, despite the breach in her rules, illustrates the way Bartlett's self-imposed structures are a marriage of convenience to be respected in some situations and ignored in others.

4. Patterson Sims, "Minimalism to Expressionism: Painting and Sculpture Since 1965 from the Permanent Collection" (New York: Whitney Museum of American Art), brochure, 1983, n.p.

5. Richard Field, "Jennifer Bartlett: Prints, 1978-1983," *The Print Collector's Newsletter 15*, no. 1 (March/April 1984), pp. 1-6.

6. Jennifer Bartlett, *In the Garden,* introduction by John Russell (New York: Harry N. Abrams, Inc.), 1982, p. 6.

7. Richard Field, *loc. cit.*

8. Nos. 190, 119, 108, 116 and 200.

The *Creek* series, in progress, consists of related works in both two and three dimensions. Specific elements, such as the white boat, oar and railing in the painting below, are recast as the sculptural boat, oar and railing forms seen in the rooftop view of the artist's studio in Paris on p. 77.

Creek 1984
oil on canvas
60 x 168
Courtesy Paula Cooper Gallery

House with Addition 1984
wood, paint
house: 43 x 45¾ x 28½
addition: 21½ x 22⅞ x 14¼

White Boat with Oar 1984
wood, paint
boat: 73½ x 37½ x 19
oar: 60½ x 7

Path with Railing 1984
wood, paint
37 x 112 x 23

Flooding the Mind and Eye:
Jennifer Bartlett's Commissions

Roberta Smith

The invitation to execute a commission for a specific client who has a chosen site and probably a desired effect in mind is a rare and not necessarily welcome honor for a painter; it's more the exception than the rule, more the province of sculptors. Nonetheless, since 1978, Jennifer Bartlett has completed six such commissions, public and private, here and abroad, giving them the larger portion of her considerable energies. Almost every one of these works marks a significant high point or turning point in her development, and as a group they add up to some of the best work she has ever done. Unlike most painters, Bartlett actually seems more at home responding to the challenge and restrictions of a commission than she does making paintings on her own, unsolicited, in the privacy of her studio, and if pursued, this affinity can provide the key to her complex achievement.

In retrospect, the commission format seems tailor-made for Bartlett. It dovetails with her personal psyche, her aesthetic temperament, her particular version of what might be called the mind-set of seventies art—an excess-prone, conflict-ridden generation of which she is a prominent member. The truth is that Bartlett was doing commissions long before anyone asked her to, and that she was in effect her own first "client," and that, in addition to her six official commissions, certain works or groups of works she has done on her own both before and since 1978 deserve consideration as unofficial "self-commissions."

Bartlett emerged at a time when reports of the death of painting, if greatly exaggerated, were also widely circulated. The confluence of

(p. 78)
Swimmers Atlanta: Seaweed 1979
oil on canvas; baked enamel and silkscreen
grid, enamel on steel plates
128 plates, 2 canvases
c. 207 x 49 overall

ideas in the air and of her own inclinations as an artist led her to evolve a kind of hybrid painting, one that related as much to Minimalism and Conceptualism, to process and installation art, and to her interests as a writer, as to the tradition of painting. Her best work is a feast of many parts: a plethora of visual and intellectual data that inundates you in a pleasurable, lulling surround, even as it prods you to roll up your sleeves and make sense of it all.

Bartlett's penchant for juxtaposing images, media, points of view, or styles in such profusion the viewer must piece together a whole part by part is of course perfectly suited for the scope of a commission. This suitability seems preordained even in the physical painting surface that has always given Bartlett's art such a distinct look: the twelve-inch-square sixteen-gauge steel plates, enameled white and gridded in gray, which provide an infinitely adjustable, durable (and fireproof) surface that holds flat to the wall like a second skin. But the affinity runs much deeper. The commission is receptive to Bartlett's increasingly multi-media concept of painting, an approach that sees painting as both an applied and a fine art, at once narrative and decorative. The commission's mundane realities — the planning required, the restrictions imposed by site or client — connect with Bartlett's problem-solving sensibility and with the combination of obsessive control and detached, nearly passive laissez-faire that characterizes her working method and her basic ideas about art.

In a way that could be called both lazy and cautious, that stems from a genuine obsessiveness but also from a flamboyant, radically un-romantic notion of creativity and skill, Bartlett sets special store by doing what she has said she would do — as if fulfilling a promise or meeting a dare. Whether the promise is to herself, her friends, or a client is immaterial; the attitude results in a mild artistic schizophrenia. In making her art, Bartlett functions a bit like two people — artist and arti-san or (more pertinent to this discussion) client and artist — with one person dictating instructions, the other carrying them out.

Her paintings always begin as a list of givens. What she will paint, how she will paint it, what she will paint with and on, which permuta-tions of form or motif will transpire — are all spelled out to the nth de-gree before she makes a move. These instructions are then executed for the most part by rote, filled in with as little revision as possible. On the one hand, Bartlett seems bent on reducing the frightening act of creation

to a series of incremental decisions; her lists enable her to sneak up bit by bit on the ambitious tasks she often sets for herself. On the other, her goal seems to be proof that art is merely a cool calculation of givens, of outside, uninvented facts (which the commissions supply in abundance) presented in new order. It also helps to remember that Bartlett is a gregarious workaholic with a penchant for uninterrupted labor that is undemanding enough to tolerate TV-listening and visits from friends. And finally she also seems to want to turn making a painting into a kind of scripted yet unpredictable performance.

Bartlett's separation of decision-making from art-making is not as strict as it was in the early seventies, when she emerged as a kind of conceptual naive painter — and when many people thought the counting and color systems she dotted neatly onto her steel plates were computer derived. Still, even today, she will admit that "the person who makes the work is a totally different person from the one who plans it all."

Bartlett's split-personality, remote-control approach — which makes her such a natural for commissions — is the most original, irreducible aspect of her art. It also makes her something of a wolf in lamb's clothing. Bartlett's work is very seductive and light, all pleasant surfaces and benign images, images so universal they almost amount to clichés. Lately gardens and pools predominate; earlier there were emblematic mountains, trees, lakes, houses, and, most of all, the ocean. There has almost never been anything so specifically personal or psychologically charged as an actual person. Rather, there's an impersonal oceanic fluidity, a continual ebb and flow to Bartlett's motifs and to the way the different parts of her most ambitious work float and swirl around you. In their emphasis on water and nature imagery, in their multifariousness of style, these paintings seem at times to be nothing but a series of reflections — of the world, of other people's art.

What generates these shimmering surfaces, however, is disturbing; there is in the work a sense of manic cerebralism and arbitrariness, a distance, even an indifference, that can leave the viewer feeling irritated. These qualities are communicated via Bartlett's awkward, slapdash, once-over-lightly way of painting — a lack of skill she systematically cultivates by working fast and constantly tackling new media. They come across in the often silly little dramas acted out, the formal sequences didactically demonstrated in her work — and in the way her schemes can blithely simplify the immensely complicated issues of life and death and art.

In planning her paintings, Bartlett seems actually disinterested in the final visual outcome. This is an attitude you might expect from an artist who makes extensive use of mechanical reproduction devices, like Warhol, but it is more startling in an artist who makes her work so completely by hand, as does Bartlett. Once she has rigorously set up her procedures, Bartlett's controlling instinct goes into remission, and she becomes completely passive and accepting. She simply follows orders, making the best of things as she goes (sometimes with minor adjustments) but otherwise accepting the outcome as yet another given, something beyond her control.

This loss of control is not entirely unexpected: in her elaborate strategies and grandiose subjects, Bartlett habitually contrives situations in which, like the many swimmers in her art, she will be "at sea," not knowing which way is up and having to struggle through. For not only does Bartlett sneak up on art making, she sneaks up on it with her eyes closed. Her a priori decisions are more narrative and verbal than visual, her point being to prove that these too can achieve full visual power and resonance. There's a cynicism to this determination but also an unexpected affirmation: the possibility that art may actually have a life of its own, in the most mundane, unmystical sense.

Consistent with what seems to be the desire to give her art a mundane yet exhilarating autonomy, Bartlett's aesthetic is riddled with a sophisticated obviousness. In a very direct, primitive, and at times self-indulgent way, she gets all her ideas from the immediate vicinity: from her life, from places she has been, from facts she has in her head (or can easily research in a dictionary or encyclopedia), from suggestions of friends and acquaintances. (Bartlett claims to be as interested in what other people think of her work as she is in her own reactions; she often rehearses the development of her next project with friends, getting responses to how it *sounds* — a practice in sync with being both in control and completely open to suggestion.)

The water, swimmer, and garden motifs that have so far dominated her work may be universally appealing art images — and are calculatedly used as such — but they also have distinct autobiographical bases. Bartlett spent the first seventeen years of her life in Long Beach, California, with the Pacific literally at her back door, and she swam in it daily; the impression it made, judging from her art, cannot be overestimated. And although such themes as the seasons, times of day, plus trees

and mountains played an active role in *Rhapsody*, Bartlett's great "self-commission," it was not until after forced intimacy with a garden in southern France that Bartlett adopted the garden-with-pool motif or started actually looking at the landscape.

In Bartlett's development, one thing leads to another with similar directness and obviousness. Bartlett gets as much mileage as possible out of each of her ideas and images. To a certain extent her career is a continual rearrangement of a very limited set of motifs, which are transformed by being recycled in new combinations, in new media, or in different sizes. Such re-presentation is how Bartlett gets her ideas across, as well as her conviction that one has only facts to react to and that there are only so many significant, broadly symbolic facts.

To understand Bartlett's work — her attraction to facts and her proclivity for commissions — it is necessary to see her art in relation to two earlier groups of artists: the Minimalists and certain nineteenth- and twentieth-century French masters, particularly Monet, Matisse, and Dufy. Both groups were all, in different ways, very "worldly," very involved, often on a quasi-scientific level, with the panorama of existing facts.

From the first group Bartlett learned the facts of modernist art. The Minimalists influenced her choice of eccentric industrial "non-art" materials, her tendency to separate conception and execution, her inclination toward dissecting and systematizing the physicalities and procedures of art from the ground up, her use of repetition as a compositional mode, her faith in a priori determinations and instructions. From the second group, Bartlett got her range of subject matter and the effect she desired her art to have: an effect that is seductive, lyrical, decorative, overwhelming, and yet based on "nothing but the facts." Like the Impressionists, Bartlett is interested in the big, obvious facts of natural existence, facts familiar to everyone and easily reduced to signs and systems: the weather, the seasons, the passage of day into night, and the way these phenomena are registered in the sky, the ocean, the landscape. You might say that Bartlett is after a modern-day, rationally derived version of "*luxe, calme et volupté*," although her idea of the rational is often capricious and arbitrary.

Capriciousness and arbitrariness may be seen as endemic to Bartlett's generation, the post-minimalist one, which spent the early and mid-seventies simultaneously mining and undermining the rich, au-

thoritarian lode of minimalist thought. While many of these reactions moved beyond painting and sculpture into conceptual, performance, process, and video art, Bartlett stayed closer than most to orthodox Minimalism, at least physically. Her steel plates might be described as a cross between Sol LeWitt's wall drawings and Carl Andre's sculptures; they clearly concur with the minimalist belief that, if painting was not dead, at least oil and canvas were. And obviously, like LeWitt's work, Robert Ryman's ravishing yet didactic examination of painting's basic components is a precedent.

Still, Bartlett also took things to non-, anti-, and therefore post-minimalist extremes, and she has more in common with her object-avoiding colleagues than has previously been acknowledged. Like Joe Zucker's paintings, her work stands as a parallel in paint to the activities of conceptual, process and performance artists who were her contemporaries in age and often her friends: Vito Acconci, Barry LeVa, William Wegman, and also Chris Burden (whom she did not know).

These artists and others tended to infantilize minimalist procedure, turning it in on itself and often literally in on themselves. In the process, they irrevocably fractured the single unity, the famous "gestalt," of minimalist art (and actually initiated the recomplication of both painting and sculpture that goes by the misnomer of neo-Expressionism today). While Judd, Andre, and Flavin set up instructions for their work to be fabricated by others, they always had a clear idea of what the visual results would be. The post-Minimalists, on the other hand, tended to carry out their instructions themselves, usually to excess or exhaustion; and, since the mainspring of their art was more verbal than visual, they frequently had no idea what the outcome would be. In the same way that Acconci sat at the bottom of the basement stairs at 112 Greene Street, blindfolded and swinging a stick at whoever ventured near, or LeVa hurled himself repeatedly into a wall, or Burden shut himself up in a locker on the Irvine campus for five days, or Jonathan Borofsky started writing down numbers, Bartlett set out to do in painting what she had said she was going to do. All these artists operated as if on a private, partly desperate dare that might have been voiced: I'm going to do this no matter what it looks like or feels like, or how other people react. Or perhaps more accurately: I'm going to do this *to find out* what it looks like or feels like.

Carl Andre
Lead-Steel Plain 1969
lead, steel
3/8 x 72 x 72
Private Collection

In every case, post-minimalist procedures undermined minimalist gestalt and turned a priori decision making into irrational open-endedness and chain reactions. While the minimalist generation ruled out the depiction of transitory emotions in favor of single essential forms that distilled each artist's passionate idea of what art should be, Bartlett's generation became fixated on thought itself — not on structure but on structuring — the ongoing process of ordering, feeling, and naming. This drive to reveal the process (and often the depths) of the mind went hand in hand with an emphasis on self-evident physical process and was as strong in the relatively austere approaches of Dorothea Rockburne, Mel Bochner, and LeVa as it was in the more excessive, accessible ones of Wegman, Borofsky, Zucker, and Bartlett.

Presenting more information than can possibly be comprehended in a single viewing or ever really held completely in the mind, the performance and installation artists often made their work exist in real time, as a measurement of time. Bartlett's work, most especially her commissions, shares this lack of unity, this temporal extension. By presenting so much information over so much surface (or so many surfaces), they frequently achieve a kind of novelistic status. They tell a story that is part narrative, part process, partly about shifts in material and media and levels of skill, partly about the nature of the natural world; and in doing so they touch on, catalogue really, many issues of seventies art in a way that is alternately satirical, passionate, and omnivorous. It may be that Bartlett has made unusually accessible the nastily radical early seventies mind-set, executing a kind of popular illustration of cool, intellectual art-making. Taking aspects from both Minimalism and post-Minimalism, she has used them to build a seemingly lush, seemingly traditional, nearly nineteenth-century picture of the world beyond.

■

Jonathan Borofsky
Counting from 1 to Infinity 1969
stacked sheets of paper
32 x 8½ x 11
Collection the artist

Each of Bartlett's commissions or self-commissions highlights a major aspect of her sensibility or signals a shift in her art. Her increased involvement with painterliness is outlined in *Rhapsody*, 1975-76, and then made adamant in *Swimmers Atlanta*, 1978. Her diversification of media is first signaled in the series of drawings *In the Garden*, 1980, and hammered home in the commission *The Garden*, 1981; it is even more extreme in the Volvo commission completed in the fall of 1984. A grow-

ing realism appears intermittently in *The Garden*, becomes more prominent in the less successful self-commissions *Up the Creek* and *To the Island*, as well as in the AT&T commission, and appears to be used more convincingly in the Volvo work.

In *At Sea, Japan*, 1979, Bartlett's love of sensuous, nearly abstract brushwork shines forth. Her essentially verbal, narrative conception of painting and her penchant for contriving stories to then be translated into paint is most overt in *Swimmers Atlanta*. The *In the Garden* mural, executed for the Institute for Scientific Information in Philadelphia in 1980, takes to literal extremes her practice of presenting many parts and leaving the viewer to assemble the whole. Over the course of the *In the Garden* drawings one is particularly aware of her talent for satire, and what might, without negative connotation, be called her decorator instinct reaches its zenith in *The Garden,* a work that offers a Dufy-like surround of *"luxe, calme et volupté"* — and a didactic *explication de site.*

With hindsight it is apparent that the main components of Bartlett's art and sensibility were in place, if undeveloped, by 1972, with her first one-person show in a commercial New York gallery. That show, at the cavernous Reese Palley space of "early" SoHo, must also be seen as Bartlett's first self-commission. Bartlett decided to cover as much of the gallery's walls as possible with new pieces, determined the ones to be executed, and "just dotted furiously" until they were finished. The approximately sixty-five resulting works, usually ranging from one to eight plates in size, mostly put color and various line configurations through a number of often elaborate demonstrations. There were also three larger pieces: one dealt, prophetically, with the theme of the house (p. 44), the other two with intersecting lines.

When the exhibition was finally installed, Bartlett had literally tiled the walls, making it difficult to tell where one work left off and another began. The initial effect was of a total overwhelming environment of painting. Bartlett's penchant for the all-encompassing work of art could not have been more apparent. Also evident were her disregard for the line between abstraction and representation and, further, her tendency to codify the latter while turning the former into sequential narratives that at times had a molecular, cartoonish animation. Sequential treatment prevailed everywhere. The plates were painted one at a time, like

the pages of a book or the frames of a film, and had to be viewed that way. This manner of viewing, already encouraged by the visual overload, was further enforced by Bartlett's use, even at this stage, of a shifting perspective that turned the eye into a kind of moving camera. Sometimes this movement was intellectual: the house is depicted at various times of day or year (as if viewed by the sun). Sometimes it is clearly, hilariously spatial: the house, the various grids, and the intersecting lines alike are zeroed in on until nearly unrecognizable, as if seen through a zoom lens. And sometimes the movement is something else altogether: in the longest sequence of plates in the house piece, the image is subtracted segment by segment in each succeeding plate — rather like a cartoon illustration of process art in reverse.

Perhaps most evident of all was Bartlett's inclination to think big and work small, to sneak up on an immense project via hand-held units covered with tiny units of paint. This sense of relentless accumulation, of the march of the dots over the plates, of the plates across the walls, gave the show an obsessively detailed intimacy that made it seem even larger than it already was — not an aspect that found universal favor.

The dots, regulated by the quarter-inch gray grids, were painted by rote, as if by a robot, yet the hand's unavoidable vagaries set up a rhythmic counterpoint to the gray grids and the larger grid of the plates on the wall. By now, Bartlett paints many different ways, some of them fairly dense, but something of this original stroke-by-stroke discreteness and relentless filling in still obtains in her surfaces and remains a constant despite her many changes of style.

■

Bartlett's most significant self-commission is *Rhapsody* (pp. 22-27), executed between the summer of 1975 and the beginning of 1976 and exhibited at the Paula Cooper Gallery in May. *Rhapsody* was Bartlett's attempt to deal with criticisms of her first two shows — the gist of which had been that her ideas made better writing than painting. Conceived of as a work of about 1,000 plates that would fill, once more, the entire gallery, it finished off at 988 and did just that. It also established her reputation in the art world, made her known to a wider public, and remains the cornerstone of her art.

To answer her critics, Bartlett did not, initially, make her approach any less verbal or intellectual. In fact, she actually upped the analytical ante by taking more facts and procedures and considering them in greater detail, but in doing so she also radically expanded her art. Specifically, she unleashed her systematizing, cataloguing instinct on the world at large and used it to break down even further the forms and procedures of painting and drawing. (This breakdown was well underway in the "nine-point" paintings [pp. 18-19], seen at Paula Cooper in 1974 and in subsequent work.) Still, in doing all this, Bartlett simply melded the two sides of her sensibility stated in her Reese Palley show. Abstraction and representation were given equal status and forced to interact within the same work of art.

In *Rhapsody*, the elements of design (line, shape, color) meet head on with some of the classic elements of nature's design (mountain, tree, ocean), plus the house, the most essential element of human design and, as depicted by Bartlett, one of the most geometric. After an introduction, or overture, which states the seven themes, a chapter-by-chapter debate of escalating complexity and sophistication ensues. The major themes are reiterated in endless variations and combinations, via three ways of painting (dotting having been joined by "measured" and "freehand" strokes) and often in three sizes (small, medium, and large). There are occasional extra-large images: a big version each of the house, the trees, and the lines span groups of plates the size of "normal" paintings.

The increasing breakdown of the plates' discreteness is symptomatic of the way *Rhapsody* and Bartlett both end up in a place much different from where they begin. As it proceeds, Bartlett's analytic bent accommodates a new arbitrariness, a tolerance for wild cards and tangents, turning into a kind of analytical stream of consciousness. Likewise, her simple display of art's basic tools gives way to a multivalent examination of uses: of modes of representation, and style, of levels of "art," even.

The schematic semi-abstract renderings of houses, mountains, and trees, descended directly from the Reese Palley house piece, lead to images of trees copied from the dictionary and seed packages, houses copied from photographs and real estate ads, and a sequence of mountain images that run the gamut from Van Gogh to Mondrian, with

"calendar art" in between. The exercises in line, color, and shape alternately evoke LeWitt, Delaunay, and Malevich.

Rhapsody can sustain unlimited looking and thinking: its intricacies deserve a nearly plate-by-plate discussion, or at least more space than the scope of this essay allows. The adjectives "novelistic" and "encyclopedic" so frequently appended to it are fitting. Still, its power comes from something very succinct: for the first time Bartlett puts her inquisitive, restless intellect right on the surface of her work, making it both easy and visually gripping to follow the workings of her mind.

Only *Rhapsody*'s final chapter, or movement, is somewhat mysterious — an extended sequence of plates dotted and painted (freehand) in a range of blues, browns, and whites. It is the ocean in a peaceful, undulating "fade-out." In a movie or piece of music, it would be corny; here it is the most minimal, abstract section, but in some ways it is also the most specific. For when Bartlett devoted the final portion of *Rhapsody* to the ocean, she let into her work a number of important things: the natural fact that had been the center of her childhood; a real-life equivalent for the fluid, illusionistic surface of painting; and a mesmerizing weightless kind of beauty and sensuousness. She also began to move away from systems using signs of the world and toward the pictorial systematization of actual places.

■

Since *Rhapsody*, water has played a major role in many of Bartlett's paintings and in every one of her commissions. The ocean particularly dominates *Swimmers Atlanta* (pp. 90-93), of 1978, executed for the lobby of a federal courthouse in Georgia's largest city. In this work, Bartlett amplifies the final ocean section of *Rhapsody* into a full-fledged narrative and integrates it with possibilities hinted at in other sections — the exuberant paint handling of *Rhapsody*'s extra-large tree image, the saturated hues of the various color sections. The decorative, painterly force of this commission is unprecedented in her work.

The space for the commission presented problems: a long narrow lobby on one entire side of a conventional glass curtain wall office building. Only twenty-two feet behind this glass exterior was the wall for Bartlett's painting, a granite surface 20 feet high, 160 feet long, and di-

Rhapsody 1975-76
detail

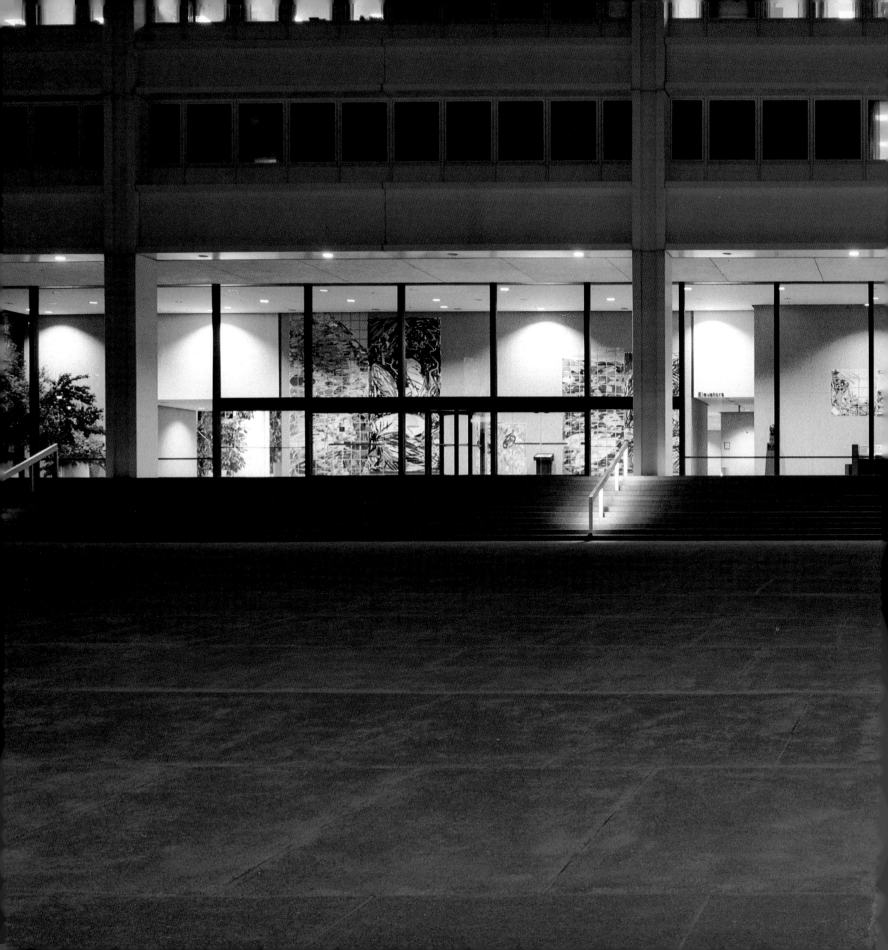

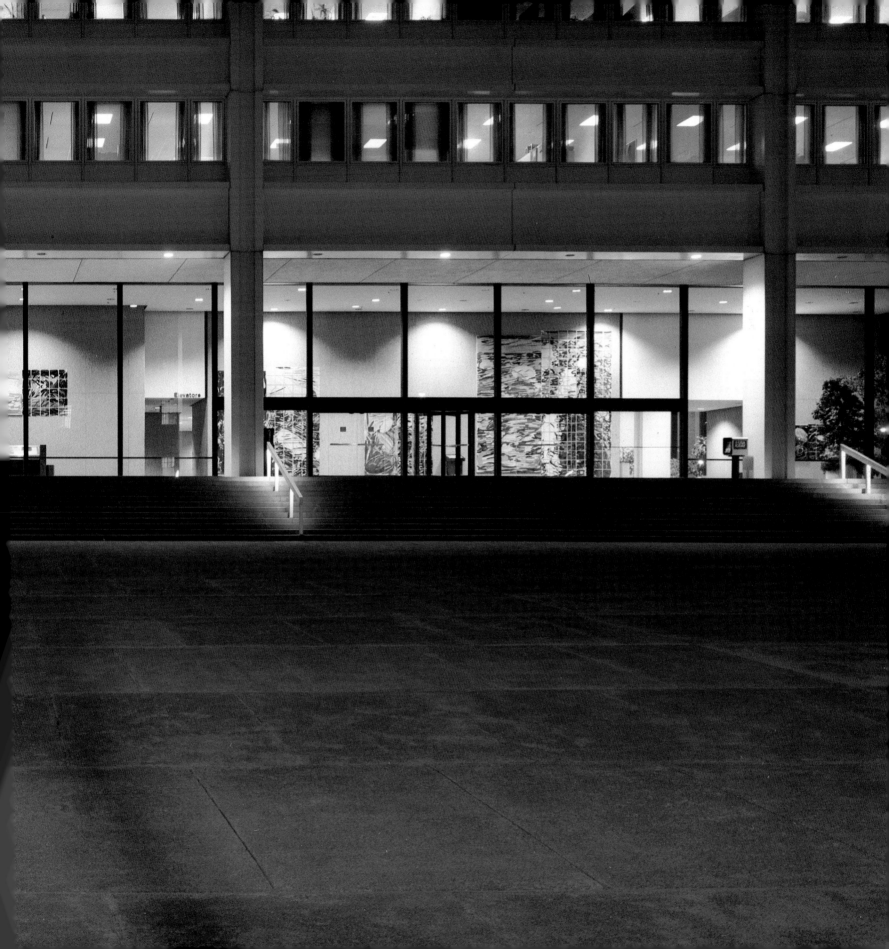

Swimmers Atlanta: Flare 1979
oil on canvas; baked enamel and silkscreen
grid, enamel on steel plates
72 plates, 2 canvases
156 x 150 overall

(opposite)
Swimmers Atlanta: Boat 1979
baked enamel and silkscreen
grid, enamel on steel plates;
oil on canvas
162 plates, 2 canvases
c. 233 x 224 overall

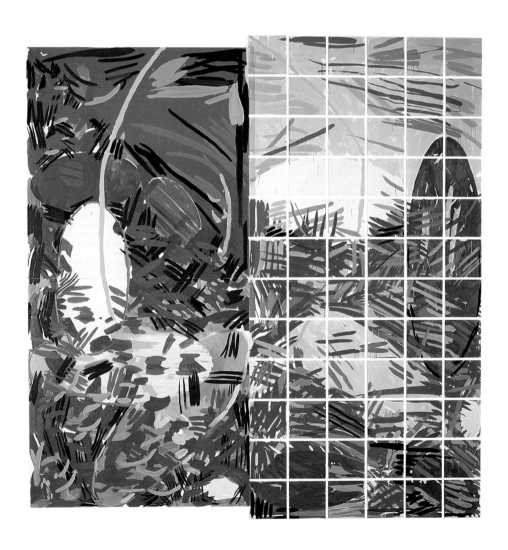

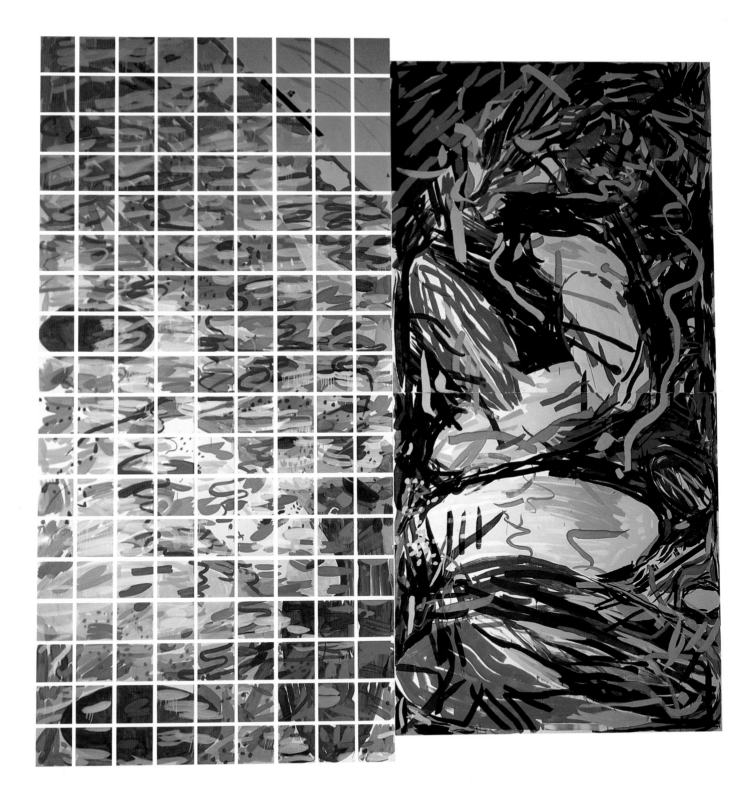

vided into five sections by wide gaps for hallways. Bartlett's solution to this unaccommodating situation was to break the work into nine related paintings that progress in size from two to eighteen feet square, in color from white and black through the primaries and tertiaries, and, for the first time, through a fairly coherent (if arbitrary) set of variations on one dramatic theme.

Thinking Atlanta was on the Atlantic, Bartlett chose the theme of swimmers and their "trials" as a metaphor for the ups and downs of courtroom life. The need for a figure was met by a characteristically schematic ellipse in a range of flesh tones. These geometric humanoids come up against a range of often hazardous facts of ocean life, with each encounter depicted in the color most appropriate. There are icebergs (white), whirlpools (black), electric eels (yellow), and so forth through flares (red), seaweed (blue), ocean liner (green), and rocks (purple). Realizing that the outcome of courtroom trials is inevitably either positive or negative, Bartlett depicted each incident twice, in a happy and a sad version, underscoring this duality with a two-sided surface. Each painting is half Testors enamel on enameled steel plate and half oil on canvas — Bartlett's first extended foray since graduate school into the traditional materials of her craft.

Once again, Bartlett bit off more than she could chew: her success at telling her stories and differentiating the happy from the sad versions is debatable. Usually, on the sad side, the swimmers are at the bottom of the ocean, or the horizon line tilts dramatically, or the waves and brushwork are agitated, or the sky is black or rainy; the reverse of all these conditions obtains on the happy side.

Although the persistence of the strange elliptical shapes and an occasional realistic detail (the toy-sized ocean liner for example) hint at narrative, the paintings are nearly abstract. Still, this is Bartlett's first attempt to find the ingredients for her art in a specific place (or the idea of one) and to convey a narrative drama that generates and is generated by the formal and physical aspects of her work. And clearly the necessity of depicting these stories had a peculiarly liberating effect, giving Bartlett the intellectual rationale she needed to experiment with a new range of brushwork.

As in *Rhapsody*, she seems to warm to the project as she goes along, moving with increasing confidence and expansiveness from squiggles for eels, to the arcs of the flares, to seaweed, and so on, and despite the

frequent obscurity of the story line, *Swimmers Atlanta* is a great pleasure to look at. As the paintings progress from private easel size to public mural size, a reverse progression puts the viewer on increasingly intimate terms with the surface, because the scale of the brushwork grows as well. Finally, it all seems big and deep enough to enter into: one is submerged, inundated, and buffeted by an ocean of paint that is alternately lush and abrasive.

Still, Bartlett did not and could not let herself go completely, a fact hinted at in the work's occasional brittleness. Having tried and failed to paint these images freehand to her satisfaction, Bartlett resorted to gridding off and enlarging, stroke by stroke, the dense little gouaches that were her preparatory studies. *Swimmers Atlanta*, with its large colorful surfaces, its extreme variety of brushwork, and its long strokes spanning several feet (and plates), is actually a carefully orchestrated semblance of spontaneity. It did enable Bartlett to become more genuinely immediate in her painting, but by temperamental necessity, she still finds ways to maintain her amateur status and keep painting at an arm's length.

■

In her next commission, *At Sea, Japan* (pp. 97-100), of 1980, Bartlett continues her involvement with the ocean as generating force for both paint and story line and achieves one of the lushest, most straightforward statements of her career. *At Sea, Japan* is actually a self-commission that found a permanent home, the library of Keio University, Tokyo; it was preceded by a smaller version that enjoyed a similar fate.

At Sea, 1979 (p. 61), the short version of *At Sea, Japan*, started out as an incidental painting executed to fill the irregular, nondescript space in a front corner of the Paula Cooper Gallery during Bartlett's 1979 one-person show. According to Bartlett, the space was one that "no one ever used, that had no definition, that was 'at sea.'" Taking advantage of the plates' flexibility, she decided to fill the area with a painting that would be about the directionless state of being "at sea," using swimmers in the form of separate canvas ellipses stuck onto the plates.

Perhaps Bartlett was feeling a little at sea herself. This was her second exhibition at Paula Cooper's since the success of *Rhapsody*; she was showing separate paintings (the *At the Lake* and *Swimmers and*

(opposite)
At Sea, Japan 1980
baked enamel and silkscreen grid,
enamel on steel plates
500 plates, 12 canvases
7 feet 6 x 80 feet 8
Keio University, Tokyo

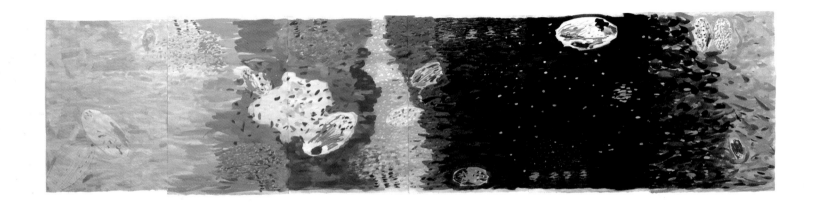

At Sea, Japan 1980
watercolor, gouache on 6 sheets of paper
22½ x 95¼
Collection The Metropolitan Museum of
Art, Kathryn E. Hurd Fund, 1983

Rafts series) and may have felt an irresistible urge to cover as much of the wall as possible.

In any event, *At Sea* was executed, exhibited, and sold, after which Bartlett expanded the piece slightly to fit the wall area in the purchaser's home. But the idea was far from exhausted for Bartlett. She began plans for a silkscreen and woodblock print of the same image and, when invited to exhibit at Galerie Mukai in Tokyo, decided to do a wraparound version of *At Sea* that would conform to the gallery's architecture.

Bartlett has referred to *At Sea, Japan* as a "soft" painting, a "fast *Rhapsody*." It is also the culmination of all her swimmers paintings, and, especially, it is a run-on version of *Swimmers Atlanta*, in which the sequence of events is simpler and easier to read, in which paint and plot are more equally balanced.

In *At Sea, Japan*, Bartlett creates an allover Monet-like expanse of brushstrokes on an eighty-foot-long surface; as in an Oriental scroll or screen, not much seems to happen, yet the totality of nature is touched on. Color dominates the action, as Bartlett's strokes change from pink to blue to gray to deep blue-black to gray again. But this is color symbolizing light and light symbolizing the earth's rotation from dawn to noon, to dusk, to night, to dawn again.

The paint is put on in loosely thatched but rather relentlessly horizontal strokes that carry the eye along as if on a current, while downward drips — physical, awkward, even sloppy — somehow enhance the sense of depth and reflectiveness. It is a day, a year, and a world seen entirely through water. Vague reflections at the top and bottom edge of the painting suggest that the swimmers pass stands of trees during the day and some lighted buildings at night. (These signs of shore life also enable Bartlett to add green, brown, red, and yellow to the prevailing grays, blues, and pinks, completing the spectrum.) The seasons are insinuated. The green trees suggest spring, the gay nighttime lights summer, without our really thinking much about it; elsewhere the sea goes white as if in a sudden snowstorm, and at another point swimmers and waves alike are dappled with strokes of rust and orange, like autumn leaves.

And, lest the viewer give in completely to the lulling rhythm of this work, there are always the swimmers — bulky little canvas ellipses appended in random groups of one, two, or three to the surface of the plates. Looking a little as if Monet had decided to give his water lilies their own physical bumper-car autonomy, they are constant, distancing

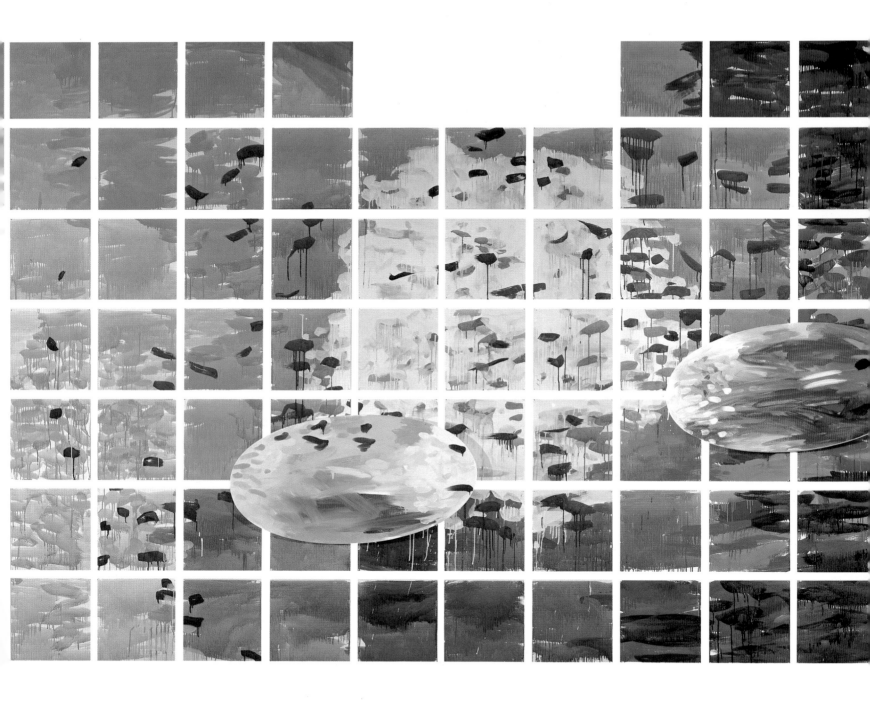

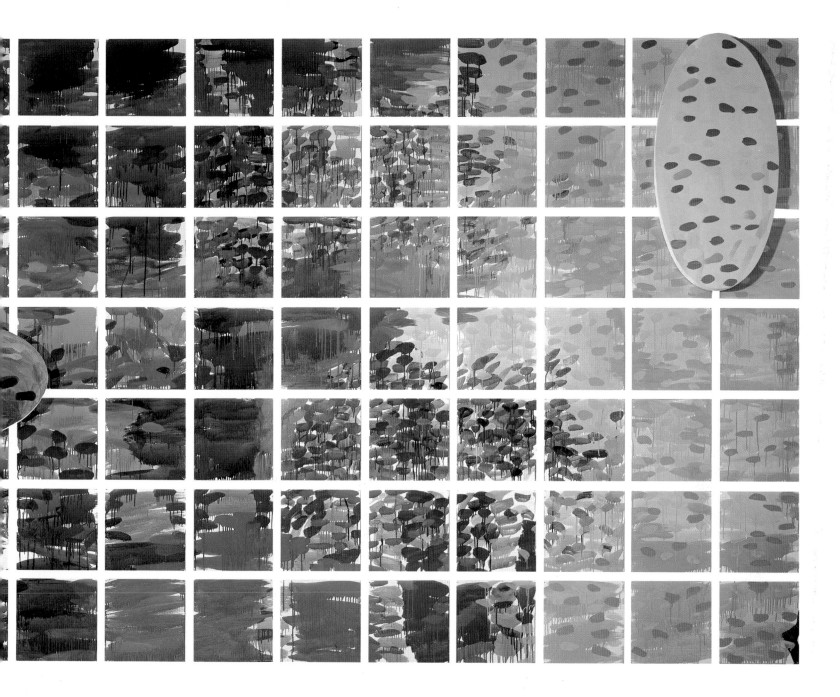

(gatefold)
At Sea, Japan 1980
detail

irritants, sardonic reminders of modern painting's literalness and of the literal-minded expedience with which Bartlett approaches the making of her paintings and the telling of her stories.

Even so, *At Sea, Japan* filled Galerie Mukai to the brim, engulfing the viewer in an environment of color, light, and brushwork. When the painting was purchased by Keio University, it was installed along a fairly continuous wall and became a permanent, commissionlike installation. The basic configuration of the plates, however, was not adjusted; it still echoes the beams in Madame Mukai's ceiling.

■

Bartlett's next commission came from the Philadelphia-based Institute for Scientific Information, a pioneer in the computerized indexing of professional and research literature with offices around the world. ISI was building new headquarters designed by Robert Venturi and, in the spring of 1980, invited Bartlett to execute a mural for its lobby on the theme of information.

While Bartlett ultimately incorporated the idea of information into the work's basic structure, her subject seemed to have had little to do with her assigned theme. She simply chose the motif that engrossed her at the time, a more "cultivated," more civilized water-swimmer duality that she had just added to her art. This new image, impressed on her mind's eye almost as indelibly as the ocean and developed, since 1980, nearly as assiduously, was that of a garden dominated by a reflecting pool with a peeing putto backed by a stand of dark cypress. During the winter and spring of 1980, Bartlett lived in a house in the south of France overlooking this scene. In retrospect it seems to have awaited her like a set stage: she drew it incessantly, working directly from nature for the first time.

The nearly two hundred works on paper that resulted from this activity evolved into the *In the Garden* series, another self-commission, more private than *Rhapsody*, but motivated by a similar need for change. While *Rhapsody* reflected Bartlett's desire to deal with external criticism, the *In the Garden* drawings (pp. 34-35) were sparked by her desire to learn to draw, and they tell the story of her progress. And while *Rhapsody* was structured around the physical constant of the plates and a kaleidoscope of changing motifs, the garden series obsessively repeats one image over an encyclopedic array of viewpoints, styles, and draw-

ing media. With it, Bartlett brings the idea of copying — copying nature, herself, or historical styles — to the forefront of her work.

For the ISI mural (pp. 105-107, 110), Bartlett chose five versions of the garden image: three were from the series, two were composites of parts of different drawings in the series — all were copied large onto the enameled steel plates. The nine-by-thirty plate mural (about 116 x 388 inches) formed by these five images presents the usual variety of natural and formal fact. Moving left to right, the brushwork varies from random to predominantly diagonal, vertical, and horizontal strokes to all-over dappling; more important, the points of view and times of day range from "bird's-eye" and morning to "worm's-eye" and nighttime.

The combined effect of all this is strange: at once frivolous and forlorn, irreverent and brooding. The drawings are translated into paintings with Bartlett's characteristic dispatch, and thus scenes redolent with nineteenth-century nostalgia receive a sharpened edge, enhanced by the plates' grid and hard surfaces. The statue, although a more explicit figure, is no less artificial than the geometric ellipse, but its fakery is that of an age-old convention, of a cliché descended from generations of stone copies. Yet the juxtapositions are also cinematic. Despite the lushness and handmadeness of the painted scenes, one is moved about, image by image, with the aloofness of a lens. Bartlett heightens these exchanges between old and new, between senses and intellect in one fell swoop, in a strategy that also brings the mural in step with ISI's information theme.

Using the mural for the lobby as an original, Bartlett proceeded to paint a second *In the Garden* mural that was as nearly as possible a stroke-by-stroke copy of the first. This second nine-by-thirty-plate mural is dispersed throughout ISI's four floors of offices in a series of fifty-four fragments (pp. 106-107) that range in size from one to nine plates each. (There are six fragments in each size.) (The copy puts to use an idea that originated with *Rhapsody* but was never taken very far — that Bartlett would paint copies of certain sections for people who wanted to buy "excerpts" of the total work.)

With the dispersed copy, Bartlett exploits in a somewhat different way the physicality of the plates and the way they "break down" any image, any set of information, their grid imposing an automatic overlay of consciousness. As anyone who moves through the building finds out, what at first seems to be a rather decorous, inexplicably gridded series of

In the Garden 1980
baked enamel and silkscreen grid,
enamel on steel plates
View of installation
Institute for Scientific Information,
Philadelphia

Using the mural for the lobby
(p. 105) as an original, Bartlett
painted a second, full-size
version of *In the Garden* whose
plates are dispersed throughout
the ISI headquarters.

In the Garden 1980
Institute for Scientific Information,
Philadelphia
details

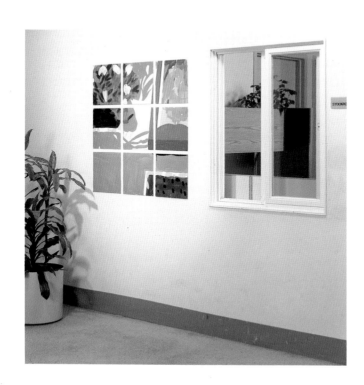

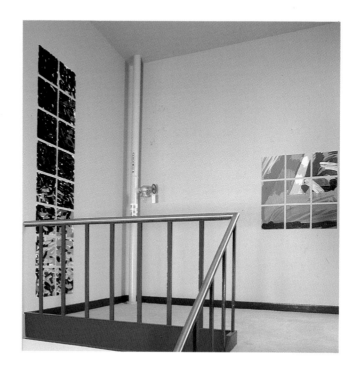

images soon becomes an exercise in the presentation, breaking down, and reassembling of visual data, a test of memory and of how much is seen at any given moment. The fifty-four fragments are there for one to ignore, ponder, reassemble, to treat as image, as abstraction, as delicious painterly morsel, and as a reminder of what's outside in the lobby, which is itself a reminder of what's beyond — a newfangled, wryly old-fashioned world of culture and contemplation.

■

In its own way, *The Garden* (pp. 115-119), executed in 1981 for the London home of the collectors Doris and Charles Saatchi, plays the same role within Bartlett's development as *Rhapsody* — it is both a concentration of ideas already in use and a ground plan for the future. Following the practice initiated with the *In the Garden* drawings and pursued in two series of paintings using the same image, Bartlett physically diversifies her painting more than ever before, while zeroing in on one specific site. In addition, and for the first time, the work is seen on the site that generated it. If *Rhapsody* amounts to both a collision and collusion between abstraction and representation, *The Garden* brings the pictorial image and its natural source into similar proximity.

Having seen Matisse's chapel in Vence during her 1980 stay in France, Bartlett became eager to try an environment made of several paintings. The Saatchis, intrigued by her interest, invited her to choose a room in their house for a commission. Bartlett decided to use the small ground-floor dining room looking out into a small pooled garden and to make that garden the work's subject.

As usual, she began by taking stock of the givens: a small, irregular, low-ceilinged room with two entrances, a fireplace on one wall and, opposite, a small leaded window giving out onto patio, pool, and trees. Because of frequent joggings and other divisions in its walls, the room divided into nine different surfaces, each of which Bartlett decided to cover with a different image of the garden in a different medium.

The media undertaken range from large-scale drawing to papier collé to lacquered-wood folding screen, to oil on canvas, glass, and mirror, to enamel on enameled steel plates, to fresco and tile. Together these surfaces and their images delineate an artificial tour of the adjacent garden's views and charms; a demonstration of pictorial ways and means both Eastern and Western, old and new, that argue for painting as fine art and craft; and a complexly cross-referenced display of the re-

flections and illusions endemic to nature, to the artifice of pooled gardens, and to art. In this way, the work is also a display of different levels of "cultivation" — that is, of degrees of realism and abstraction, of attention, and of skill. Despite its luxurious surface, it has a didacticism that dissects and enumerates the scene instead of simply depicting it. Via juxtapositions of long shots, close-ups, variations in times of day and year and kinds of light, and the listing of barely noticeable details, Bartlett reveals not only what the garden looks like but different ways of seeing it and thinking about it.

First, just inside and to the right of the door, is a blunt charcoal drawing of the garden's ornate wrought-iron gate — which is in fact visible just outside the same door. Next, as we move counterclockwise, the pool is seen from afar, an aerial view in deep blue papier collé that evokes a starry summer night. We move a little closer with the lacquer screen that, in enumerating the leaves of all the garden's trees, suggests spring; and we come closest of all with the shimmering summery green of the oil-on-glass image — the only one that shows the pool's steps and invites submersion. Next, in oil on canvas, the pool is darker, with autumn leaves floating on its surface. In a plate painting, which uses Bartlett's familiar dotting technique and depicts the gables of the Saatchis' house reflected in the pool's surface, the faded blues and silvery tones suggest winter. Winter might also be the season in the fresco image of the pool, all white and pastels. An image across the room (adjacent to the papier collé) underscores this possibility: it is the depiction on mirror of a single black tree, bare-limbed. From certain angles, this mirror reflects the pale fresco pool image in such a way that the tree's stark silhouette is added to the chilly scene.

In this work Bartlett tackles a range of new media and the combination of her determination and frequent lack of experience imparts a wonderful imbalance and brittle-lush edge — more Dufy than Matisse — that works in her favor. The eye bounces around the room, taking in the images, the viewpoints, and also Bartlett's shifting levels of skill. Her control with the plates and with oil on canvas is evident. With the lacquer screen, oil on glass, and papier collé images you can feel her adjust her grip to fit the medium. The far-off aerial view of the pool, all blue night sky and clouds, is broad and general, perfect for the collage elements' wide sweeps of color and roughly scissored outlines. The combination of information and primitive decorativeness that Bartlett con-

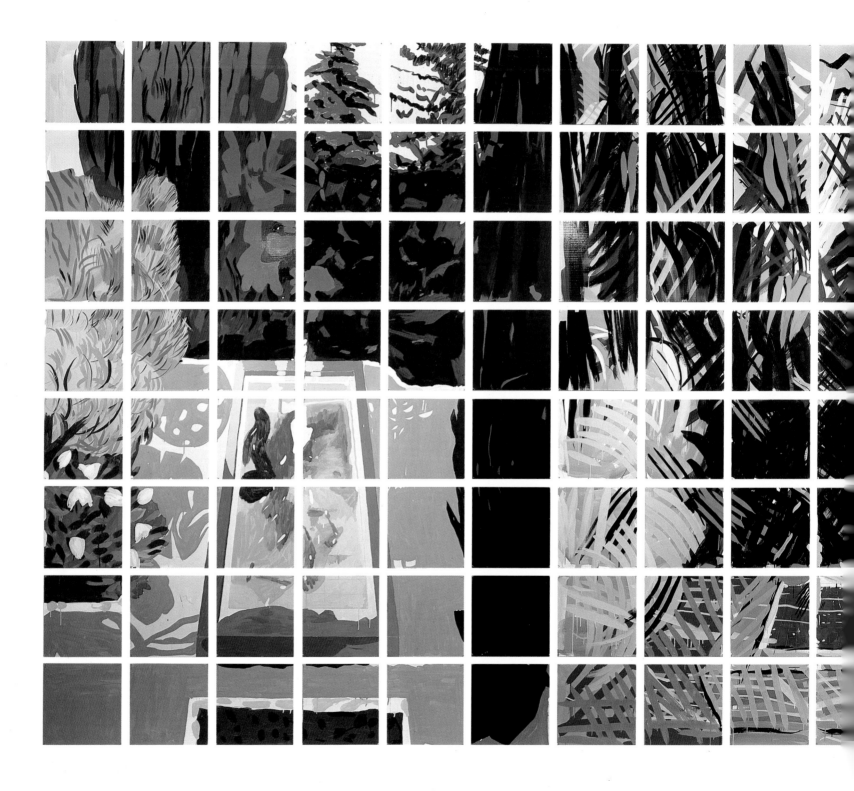

The Garden 1981
installation in 9 parts
Saatchi Collection, London

(opposite, pp. 117 and 118)
Plaka on paper collage mounted on
canvas; Plaka on wood frame
84¾ x 88¼

lacquer and enamel on 6 wood panels
screen: 72 x 126

charcoal on paper
73¼ x 81¼

Plaka on plaster wall
96 x 171¾

ceramic tiles on plaster wall
96 x 60

baked enamel and silkscreen grid,
enamel on steel plates
88¾ x 101

oil on canvas
90 x 78

enamel on glass
93 x 48

glass
10 x 81

mirror
31 x 81

oil on mirror
93 x 49

denses into the lacquer screen seems appropriate to its exacting technique. Framing a small rendition of the pool, the garden's different leaves are precise and flat as if pressed between the pages of a book. A scattering of lines and angles in shades of gray are actually copied from the grout lines in the flagstone patio. The final touch is a double portrait, close up and far away, of Buster, the Saatchis' cat. Thus the screen amounts to a partial listing of the site's plant, animal, and mineral life, reprising the information-gathering obsessiveness of Bartlett's early work.

On the other hand, absence of fit can be equally propitious: the rough rendition of the pool in fresco, which frames the tiled fireplace, is so worked, it appears actually to have impasto. Big and expansive, it is one of the most energetic images in the room, confirming the importance of Bartlett's amateur status and the primitivism that infuses her work when she is learning a new medium.

The Garden is the first work to embody an enduring aspect of Bartlett's life and personality: her consuming interest in interior design and furnishings. Bartlett literally furnishes the dining room with her art and determined craft. The room bears a curious resemblance to work by the Omega Workshop, started by the English critic Roger Fry in London in 1913, where fine artists of various inclinations tried their hand at a range of arts and crafts. Trying her own hand in this nonchalant tour de force, Bartlett succeeds in questioning the divisions between art and craft, amateurism and mastery, and reality and illusion.

■

In the three years following the Saatchi commission, Bartlett executed two self-commissions and an official one, works whose often impressive parts but less successful wholes suggest a transitional phase for the artist, as if she were grappling with the new possibilities released by *The Garden*. For different reasons all these works seem tamped down and almost anonymous: the sparkling quality of Bartlett's mind and her visual humor is absent, but from what the pieces are not can be gained a clearer sense of what Bartlett's art is.

Like *The Garden*, the two self-commissions entitled *Up the Creek* (pp. 121-123) and *To the Island* (pp. 125-127) are multimedia, multipainting ensembles. They cover the same range of nine media — including portable frescoes! — to which a tenth, pastel, is added, and they in-

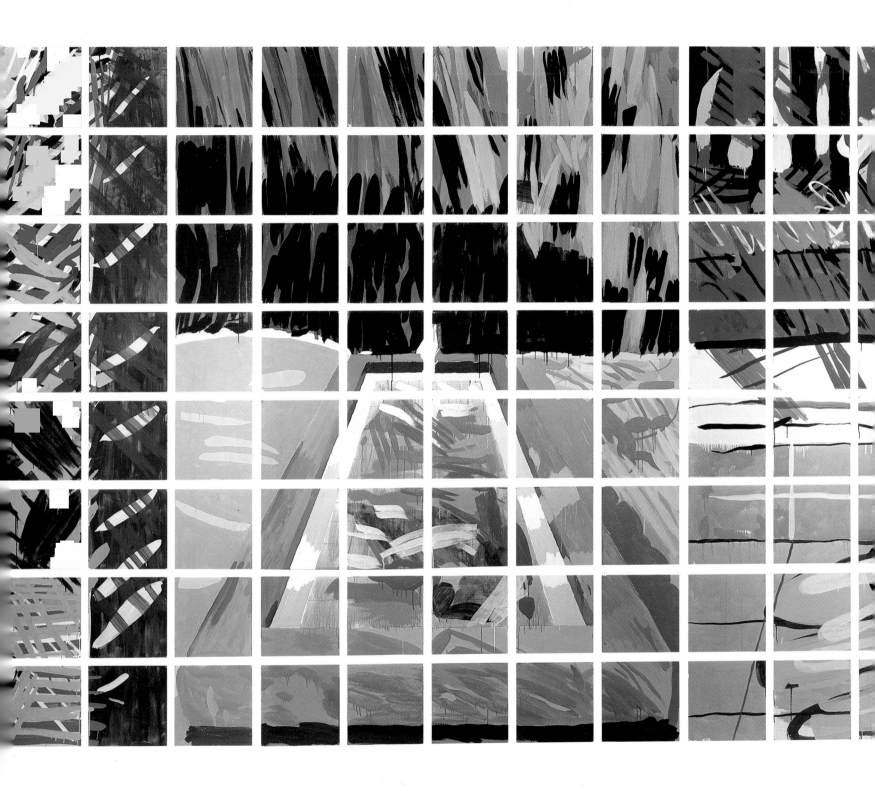

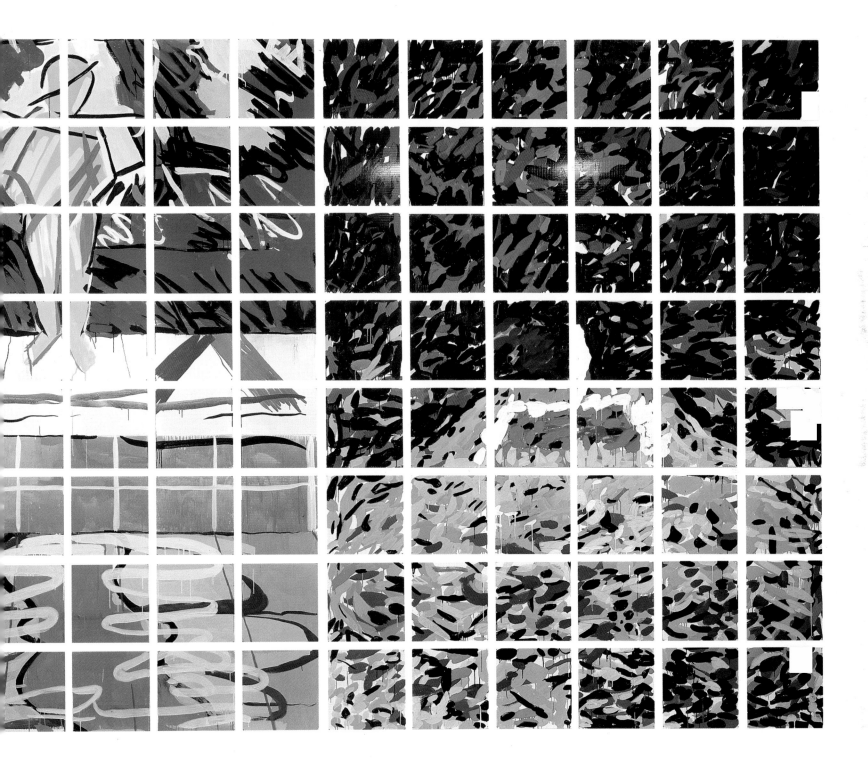

(gatefold)
In the Garden 1980
baked enamel and silkscreen grid,
enamel on steel plates
lobby installation: 270 plates
9 feet 8 x 32 feet 6
Institute for Scientific Information,
Philadelphia

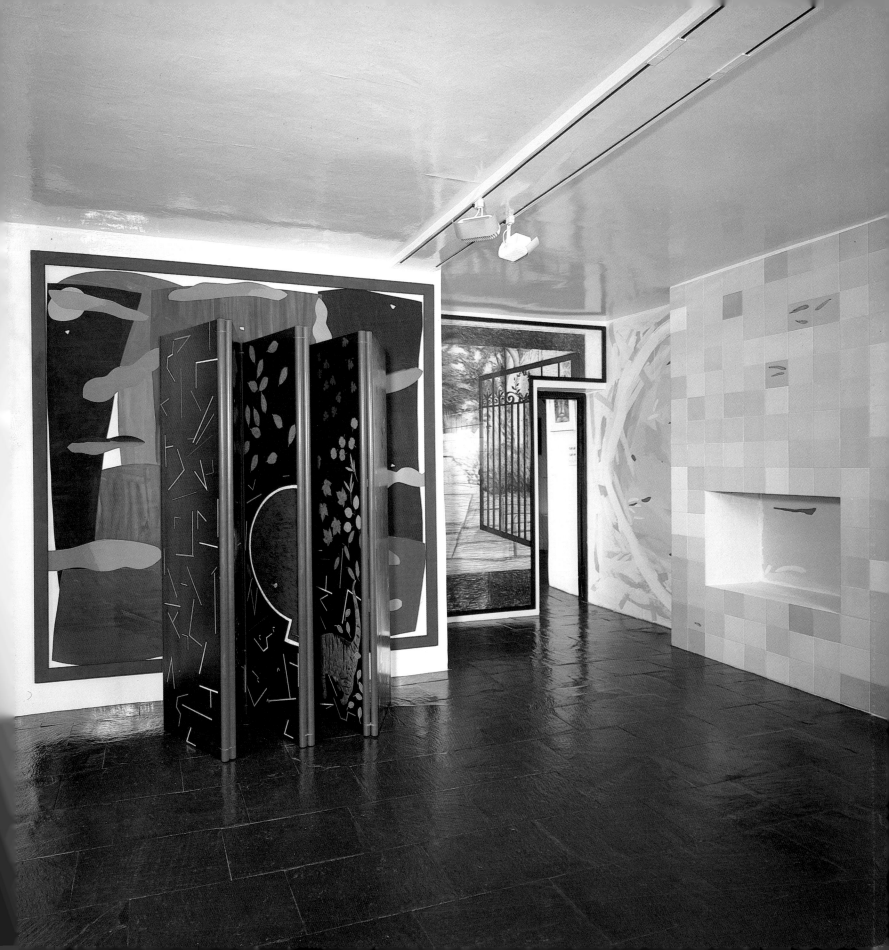

The Garden 1981
detail: screen
lacquer on 6 wood panels
72 x 126

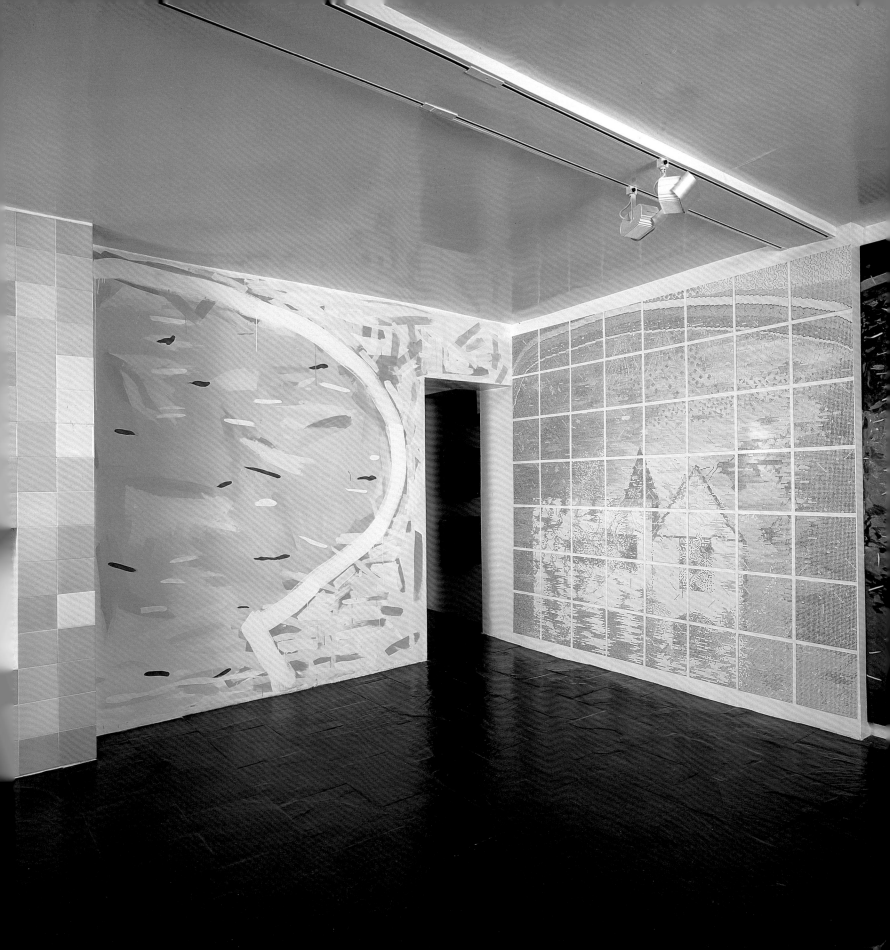

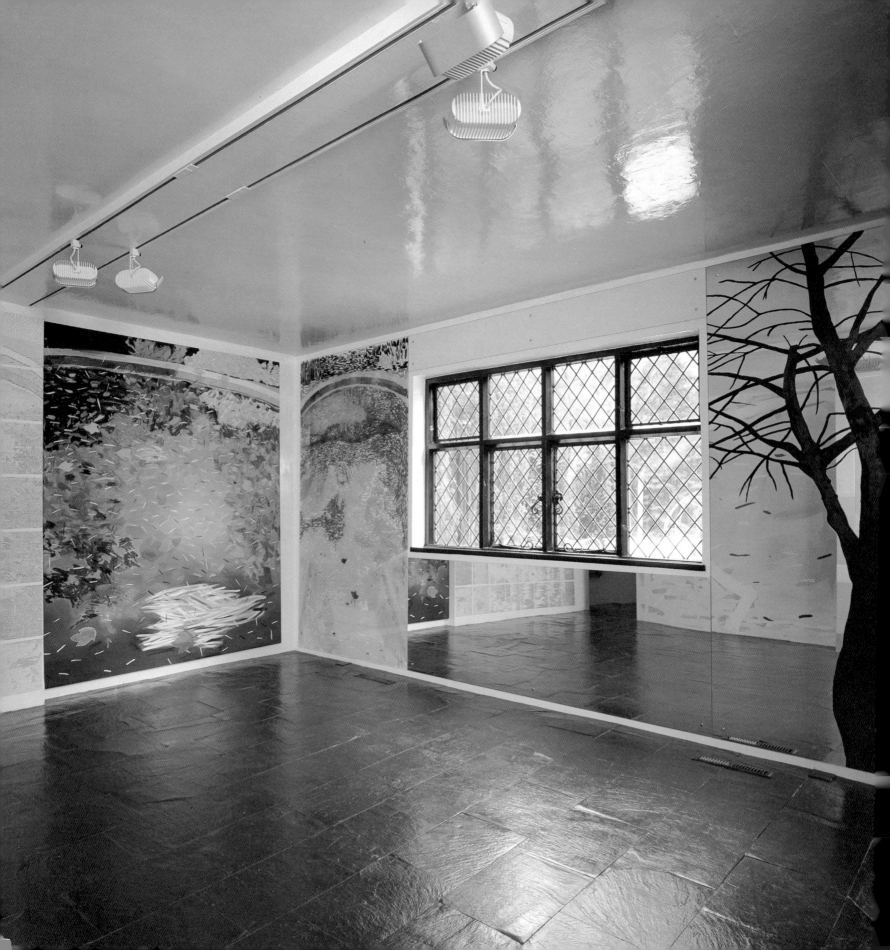

The Garden 1981
detail
enamel on glass
93 x 48

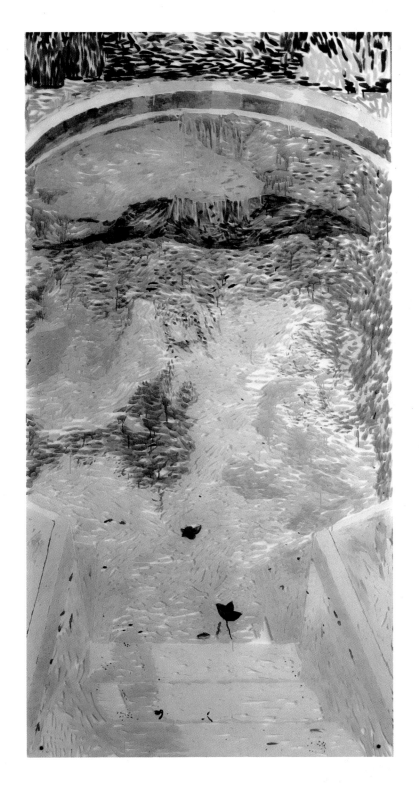

dicate the strength of Bartlett's commitment to "ensemble painting." She was clearly willing to pursue it on a very ambitious scale in the absence of an actual commission, and this absence, in fact, may have been part of the challenge.

Executed during the winter and early spring of 1981-82, the two works comprised her exhibition at Paula Cooper in March. They were based on places Bartlett had visited and also photographed extensively: a wooded and rocky creek behind a friend's house north of New York City and the shores and surrounding waters of the Caribbean island, St. Barts. Once more we are taken on a tour of places, viewpoints, and media. *Up the Creek* includes scenes of the rocky creek bed, water, wooded banks, and nearby meadows in various greens and browns. *To the Island*, dominated by subtle pinks and tans, plus vibrant azure blues, depicts images of water, coral reef, foaming beach, the island seen from afar, and a swimmer underwater. Although *To the Island* is thematically and coloristically more attuned to Bartlett's other work, *Up the Creek* is stronger. Each has wonderful things to look at — especially the lacquered wood screens, which continue to give Bartlett a certain necessary resistance.

While these works are beautiful and evocative at least of a *type* of place, they remain general both spatially and as art — they don't actually come together as a unit, nor do they project a strong enough sense of Bartlett herself. Their lack of anchor reflects two related problems: their separation from the site that inspired them and an increasing realism precipitated by Bartlett's exclusive reliance on photographs. Both problems underscore how felicitous were the circumstances of the Saatchi commission. Although Bartlett did use photographs in making that commission, she also made certain images on the site — turning the dining room into a private studio for a couple of months. While the fact that the work is seen next to the site that generated it is important, equally significant is the fact that the size and sequence of the components were determined by a particular *installation* site. The parts of the piece were physically tailored to a given architectural setting — whose smallness, it should be noted, also concentrated their impact.

These contrasts sharpen our view of Bartlett's art, particularly as pertains to her "style" and her need to have a particular site in mind — both as source and as destination for the work. In habitually touching on a range of styles and systems of depiction, Bartlett always calls into

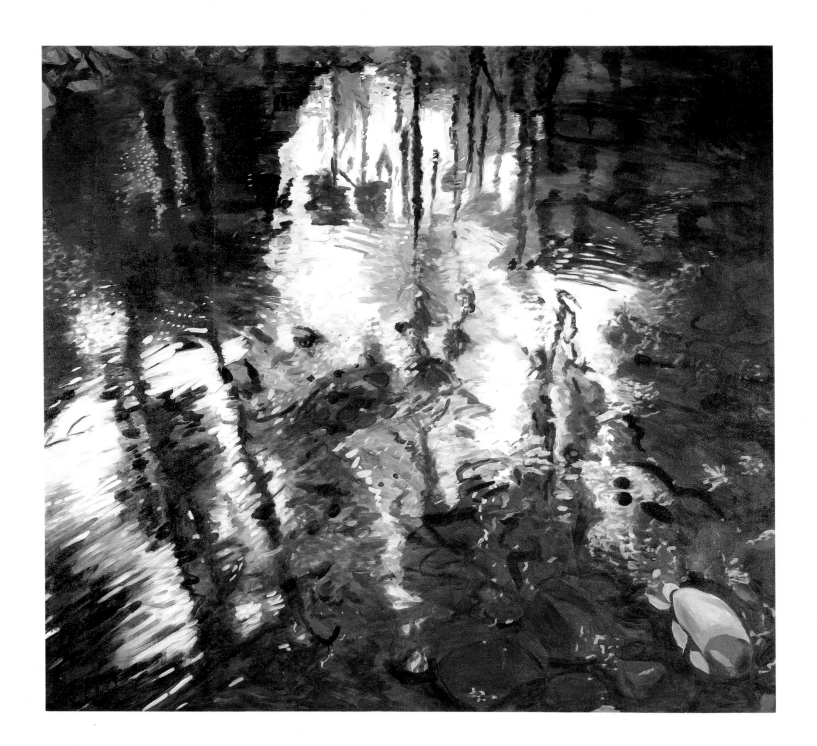

Up the Creek 1981-82
installation in 10 parts
Courtesy Paula Cooper Gallery

(left to right)
pastel on paper,
oak frame with oil paint
98½ x 74½

charcoal on paper,
oak frame with oil paint
74½ x 98¼

collage, casein on paper
on canvas, wood frame with casein
85⅜ x 85⅜

baked enamel and silkscreen
grid, enamel on steel plates
116 x 77

enamel on glass
72 x 82½

(opposite, left to right)
oil on canvas
84 x 84

folding screen: enamel on cherry, maple,
oak, pine, poplar, walnut
72 x 109½

oil on mirror
72 x 82½

oil on canvas
84 x 96

casein on freestanding plaster wall
77 x 77 x 4⅞

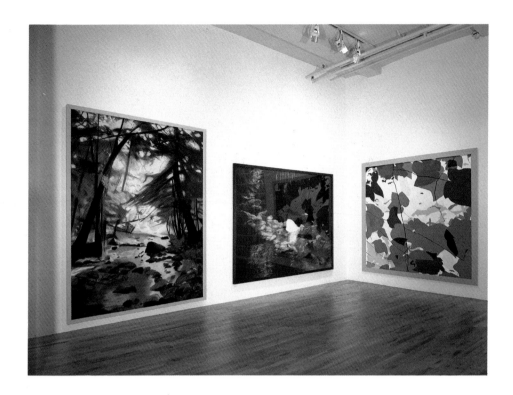

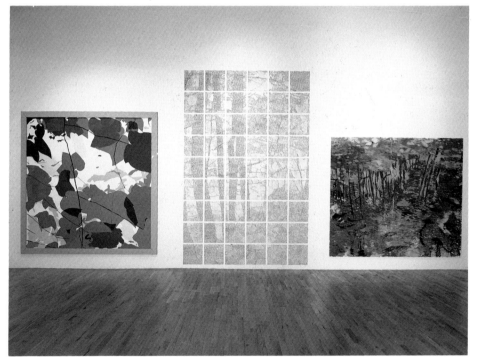

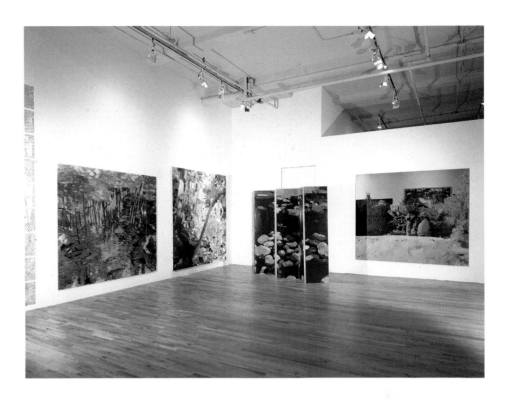

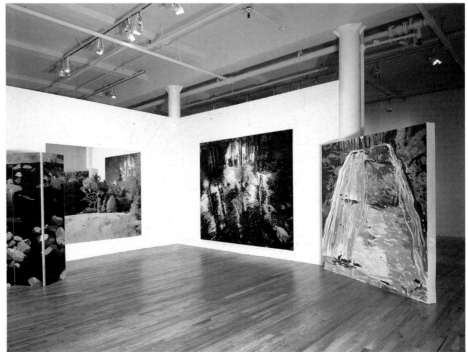

question the idea of personal style, implying in the process that she herself has none. But *Up the Creek* and *To the Island*, overly restricted to the realist end of the style spectrum, downplay the suggestions of the abstract, the primitive, of decoration and craft that characterize much of her art, and these qualities are missed. In these works Bartlett takes her reactive, aesthetically passive sensibility to new extremes, but she also proves inadvertently how distinct and personal, at its best, her non-style really is.

The official commission in this transitional phase came from AT&T for the staff dining room of its controversial new New York headquarters, the "Chippendale"-topped, postmodern skyscraper designed by Philip Johnson. Bartlett proposed a work consisting of two nine-by-thirty-foot murals (pp. 128-129) at the east and west ends of this large, high-ceilinged room — to depict the Atlantic and Pacific oceans on plates and canvas respectively — plus a group of thirty drawings in different media of different American locales to hang in each of the dining booths lining the north and south walls in between.

AT&T rejected the idea of the drawings, and, to compensate, Bartlett made the large paintings more explicit. The results have a heaving Nordic grandeur that suggests a Winslow Homer seascape done large; they present a series of contrasts in light, material, and especially viewpoint. The loosely painted Atlantic image presents a distant shoreline seen from a shifting perspective at sea. Darker at bottom, it shows light moving west as if one were watching dusk approach the American coast. The more precisely rendered Pacific image is pre-dawn — a beach-side view that moves from sand and foam at the bottom to distant gray-lighted ocean at the top. These two images take us across the country. Their implied positionings of the viewer are diagrammed in single-plate images from *Rhapsody*'s overture. The "at sea" Atlantic image also occurs in certain *Swimmers Atlanta* paintings and in *Coming to Shore,* 1979. The "on land" Pacific view was, of course, further elaborated into *Rhapsody*'s closing ocean section, nearly abstract but already mural-sized.

Both images place the viewer in vertiginous positions. On the Atlantic side, the shoreline drops precipitously at one point, breaking the gridded image self-consciously (as if it were a montage of two different images) but also subjecting the viewer-as-swimmer to some strenuous buffeting. On the Pacific side, one is looking down at the beach; the

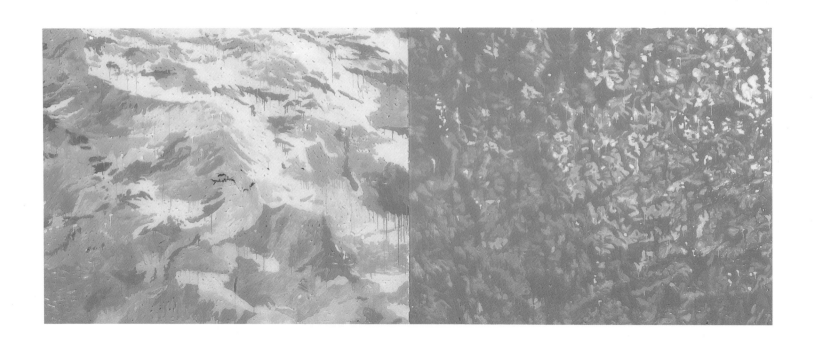

To the Island 1981-82
installation in 10 parts
Courtesy Paula Cooper Gallery

(left to right)
collage, casein on paper
on canvas; pine frame with
casein
$102\frac{3}{4} \times 72\frac{3}{4}$

baked enamel and silkscreen grid,
enamel on steel plates
116×77

oil pastel on paper,
pine frame with white
enamel paint
$74\frac{5}{8} \times 98\frac{7}{8}$

oil on canvas
72×84

enamel on glass
66×168

(opposite, left to right)
folding screen:
enamel on mahogany, sprayed
with enamel
$72 \times 131\frac{3}{4}$

prismacolor pencil on paper,
pine frame with oil paint
$74\frac{5}{8} \times 98\frac{7}{8}$

oil on mirror
83×80

oil on canvas
84×120

casein on freestanding
plaster wall
2 sections
$66\frac{1}{2} \times 85\frac{1}{2} \times 3\frac{1}{2}$ each

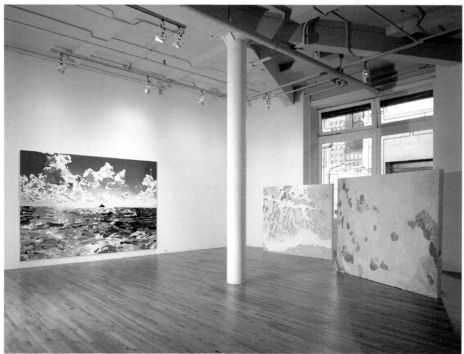

scale is slightly indeterminate. We could be on a moderate cliff but more likely we are on the beach itself, which gives us the structure of small giants. In both instances what dominates is scale, a sense of the ocean as powerful infinite mass. These are the least benign of Bartlett's ocean images — they depict nature as stark and indifferent — it is as if Bartlett were being completely realistic about dangers she has previously treated in a more lighthearted, decorative manner.

As in the two preceding self-commissions, the nearly anonymous realism of the images is something of a problem. The work also implies that Bartlett may be at her best, or at least most herself, when doing more, rather than less, and that two surfaces are not enough to ignite the physical, narrative, and perceptual crossfire that distinguishes so much of her work. But the commission's biggest problem is simply the more-oppressive-than-usual corporate dining-room decor. This room is a symphony in institutional browns: neo-Williamsburg tables and chairs, Naugahyde upholstery in the dining booths, thick plush carpet, and slickly varnished, shoulder-high wainscotting. Powerful as Bartlett's ocean images are, they are definitely undermined by this brown vastness. It's much more interesting to imagine their impact had they been allowed to fill entire walls, floor to ceiling, in the cleaner, emptier spaces characteristic of Philip Johnson's pre-postmodern phase.

■

Bartlett's most recent commission, executed for Volvo's executive headquarters in Göteborg, Sweden (pp. 132-137), and completed in the summer of 1984, may correct many of the problems that haunt *Up the Creek, To the Island* and the AT&T commission. This is, once more, a work of many parts and media that will be seen only on the site that inspired it. And not only does this work depict the site, it moves out into the site and to a certain extent disappears.

The Volvo building, designed by Romaldo Giurgola, is situated on a wooded hillside that has a distant view of archipelagoes; the spaces available to Bartlett were a reception room, a dining room, and what Volvo calls a "relaxation" room overlooking this view. The commission Bartlett devised consists of two paintings (one on plates, one on canvas), one large pastel, a fresco, a lacquered wood folding screen, a portfolio of drawings (the last two were executed on the site), and, for

(opposite)
Atlantic Ocean 1984
baked enamel and silkscreen grid,
enamel on steel plates
103 x 350
American Telephone and Telegraph Building,
New York. Commissioned by AT&T

(above and opposite)
Pacific Ocean 1984
oil on canvas
96 x 360
American Telephone and Telegraph Building,
New York. Commissioned by AT&T

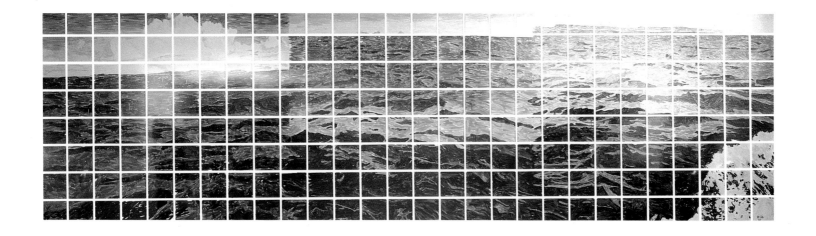

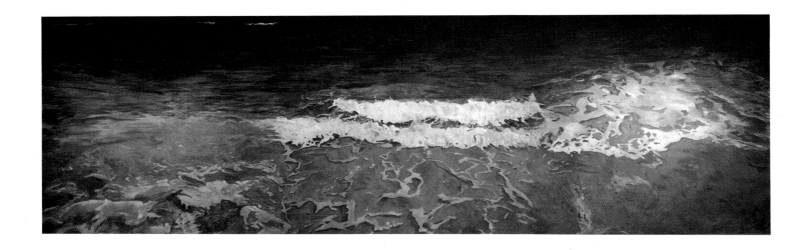

Commission for Volvo Corporation
headquarters building, Göteborg 1984
reception room
detail
baked enamel and silkscreen grid,
enamel on steel plates
87 plates
129 x 132 and 39 x 67

(opposite)
Volvo Commission 1984
outdoor sculpture
table and two chairs
granite
table: 29 x 35 x 35
chairs: 35 x 18 x 18

Volvo Commission 1984
outdoor sculpture
detail of house interior
table and two chairs
copper
table: 29 x 35 x 35
chairs: 35 x 18 x 18

the first time, several three-dimensional objects installed both inside and outside the building. Without seeing more than the two paintings and the pastel in Bartlett's New York studio, as well as many photographs of the completed ensemble, plus some blueprints and drawings, I can only speculate about this work in the light of her previous efforts, but such speculation is exciting.

The reception room is dominated by four images of scenes outside the building. First, a plate painting of the shore, the water, and a small rock island in the pinks, greens, and browns of sunset, painted in a new way Bartlett calls "freehand dotting." Next is a densely wrought, colorful pastel of birches next to a stream mottled by sunlight and shadow. Adjacent is a very austere image on canvas of one of the rock archipelagoes primarily in blues and browns. And finally, on a curved wall of a small alcove directly behind this canvas is a roughly painted fresco, white on blue, of clouds in the sky.

These four large images contrast techniques, levels of skills, degrees of abstractness and decorativeness, and approaches to working from photographs in ways that return Bartlett to solid ground. The plate painting is a quiet version of the torrential, impressionist brushwork in *At Sea, Japan* and has much of its abstract decorativeness. The inlet image, which represses gesture as entirely as the preceding one acommodates it, is more realistic but so blunt and severe in composition that it introduces another kind of abstraction. The pastel image, a sudden outburst of rendering expertise, offers such a profusion of color and detail that its realism becomes quite decorative in its own way. The white-on-blue fresco, the most bluntly freehand, gestural surface of all, nearly reduces reality to flat decorative pattern.

The next three parts of this commission are sculptures visible from the windows of the dining room that comes after the reception room. From the first window is seen a very plain granite table and two chairs, life-size. The second window looks out on a small, square, one-room house in the indigenous style of a Swedish summer cabin — with white-painted vertical clapboards, a copper roof and a dirt floor. Inside this house are another table and two chairs, this trio in copper. From the end of the dining room are visible two full-sized rowboats made of Cor-Ten steel, one resting rightside up, the other upside down, as if temporarily out of use.

In a way that is bold and startling, but also consistent with her continual annexation of new media and materials, Bartlett has simply dimensionalized motifs of longstanding use. The house has been a recurring motif since her 1970 *House Piece*. Also present but little noticed in that work are the blocky, schematic table and chairs, glimpsed in a four-plate sequence that takes us up to, then through the house's front door and into its interior. Besides making three minor but endearing appearances in *Rhapsody*, the boat is the implied, often conspicuously absent element in many of the swimmer paintings.

The final relaxation room contains a third group of works that sums up everything that has come before — twice, in fact — and with utmost discretion and lightness. On a six-panel folding screen the three-dimensional objects just seen from the preceding rooms are depicted in their respective, quite different bits of landscape. Thus, the table and chairs, house, and boats, first encountered in real space, are returned to the realm of the pictorial.

This room also contains a final table and chair made of wood and painted a pale yellow indigenous to much Swedish furniture. On the table, a portfolio of twenty-four ink drawings Bartlett has done on location is available for viewing: these images recapitulate the landscape and the elements of her commission in a range of styles — in all, a reprise of the strategy of the *In the Garden* drawings paired with the on-site viewing built into *The Garden*. Beside the portfolio sit a small, white enameled wood version of the house with a removable roof — it contains a deck of cards and cigarettes — and a miniature boat, cast in silver, which can double as ashtray. In this final form the entire work — its range of subjects, its oscillation between image and object — is brought together, simply and intimately, on a single table top. It is somewhat as if Bartlett, à la *Rhapsody*, were executing another low-key fadeout, and yet it is also here, once more, that she nonchalantly pulls the whole ensemble together.

So far Bartlett has avoided calling any of her new objects sculpture, nor does she agree with my suggestion that they are "three-dimensional images." It's hard to know if she is further expanding her definition of painting or now on the way to becoming an architect-designer — as well as a painter — fulfilling her ambition to do "everything in a given space." Whatever the case, it's clear that real space and materials have

(opposite)
Volvo Commission 1984
outdoor sculpture
house
white painted wood with copper roof
118 x 118 x 118

Volvo Commission 1984
outdoor sculpture
two boats
Cor-Ten Steel
110 x 51 each

Volvo Commission 1984
detail
oil on canvas
216 x 102

Volvo Commission 1984
detail
pastel on paper
134 x 85

(p. 135)
Volvo Commission 1984
relaxation room
detail
table and chair: painted wood
table 29 x 35 x 35
chair 35 x 18 x 18
portfolio of 24 drawings
pen, brush and ink on paper
20 x 16

house cigarette box
painted wood
5 x 5 x 5

boat ashtray
silver
5 x 2

screen
enamel on 6 wood panels
72 x 123

become another place for Bartlett to take her forms and her ideas. These additions give her more room in which to explore, contrast, and make distinct the issues she finds most compelling, and so to further intensify the crossfire in her work.

As in the two-dimensional works with which this commission begins, the objects syncopate different media and craft, different levels of realism, function, and decoration. The table and chairs are schematic, the house less so. The boats, precisely translated into Cor-Ten, are finely detailed; they seem to offer up each element of their structure as a separate entity, as if in complete self-explanation. Now carpentry, metal work, casting, stone carving and furniture-making are added to Bartlett's already long list of media: three dimensions are played against two, life-size against hand-held, handmade against fabricated.

As Bartlett takes us from one real or depicted vista, one large or small object to another, it becomes obvious that the figure in her work has also been dimensionalized — has ceased to be the swimmer or the statue and become the viewer. This metamorphosis has been underway for some time. It is especially apparent in the Saatchi commission, *Up the Creek, To the Island,* and the AT&T murals — all of which offer dramatically specific lines of sight and scenes either big or real enough to step into. Furthermore Bartlett's objects stand in for the absent figure. Like their building processes, their forms also signal a range of human activities both recreational and essential. The house signifies shelter and vacationing, the boats sport and labor. And in this melange of things to look at and things to use, form is often thrown off function's scent.

Bartlett may never again include a house for cards and cigarettes or an ashtray-boat in her work, but the fact that she has done so here substantiates more than her flexibility and her catholic, non-hierarchical approach to the ways and means of art. The manner in which this work expands into real space and then contracts down to the final somewhat whimsical table top has a combination of charm, certitude, and accommodation which, if characteristic, has also never been so clearly nor so elaborately stated.

Like the double symbolism of house, boat, and furniture, these parting details play out in a minor key, Bartlett's conviction that art is a source of very real lessons and very real pleasures, small or large, mundane or grand. Like much of her work, the Volvo commission demonstrates how the pleasures and lessons of daily life, nature, and art feed

Volvo Commission 1984
reception room
detail
fresco: Plaka on plaster
134 x 106

off of and back into each other and how their intricate reciprocity can be cultivated to particular effect by invoking that place where they often overlap: the garden. As always in Bartlett's undertakings, this ensemble work represents the cultivation of the obvious, of the given facts of a real situation into a work of art. In being so "site-specific," the Volvo commission brings Bartlett closest to the early seventies' process and installation art which helped form her painting, while also expanding on the notion of *plein-air* painting that started with the Impressionists. In both ways, the work becomes an extended improvisational performance with permanent results. What Bartlett has done is add to the scenes of *"luxe, calme et volupté"* that the Impressionists, among others, so loved to paint, and then proceeded to paint them herself.

For the present at least, Jennifer Bartlett has said she will do no more official commissions, that she now wants to work exclusively for herself. Of course, the extent to which she has succeeded in working for herself all along, following her own dictates while meeting the requirements and expectations of others, is remarkable. But it is equally apparent that commissions came to supply Bartlett with an ingredient essential to her growth: a site, a prevailing sense of place in which to ground each work. In Bartlett's newest efforts, which build directly on the combination of image and object introduced in the Volvo commission, she seems to have ended this dependency, closing the gap between both official and self-commissions and the rest of her work, making them all one and the same. It may well be that her new use of objects has set Bartlett free, giving her a kind of place that she can carry with her, a situation to re-create and create from, wherever and whenever she desires.

Plates

Color Index I 1974
baked enamel and silkscreen grid,
enamel on steel plates
25 plates
64 x 77
Collection Mr. and Mrs. Donald M. Cox

(opposite)
2 Priory Walk 1977
baked enamel and silkscreen grid,
enamel on steel plates
64 plates
103 x 103
Collection Philadelphia Museum of
Art. Purchased: Adele Haas Turner
and Beatrice Pastorius Turner
Memorial Fund

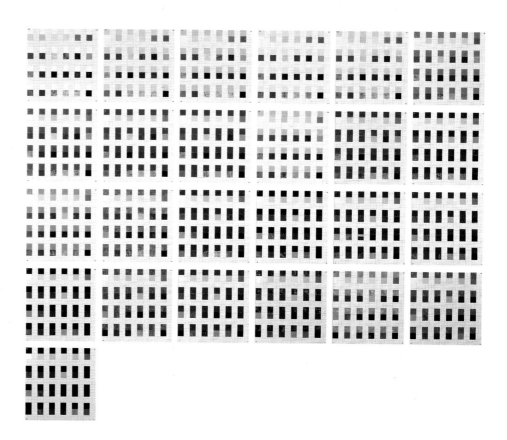

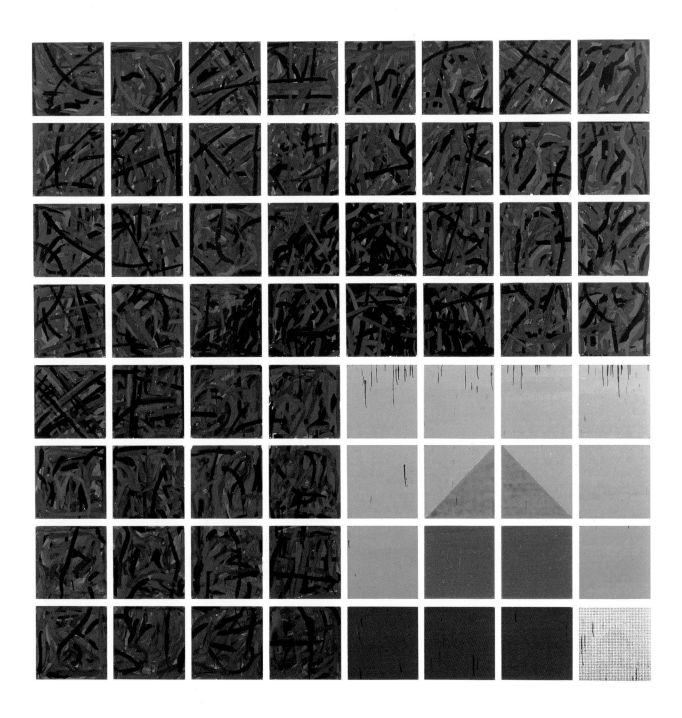

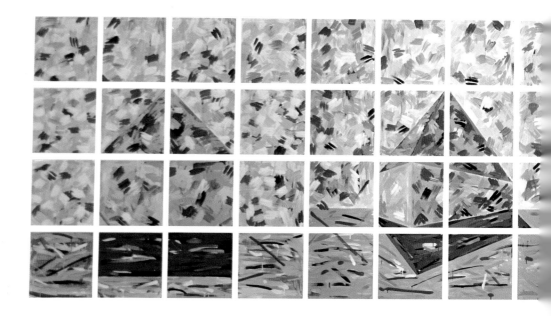

123 East 19th Street 1977
baked enamel and silkscreen grid,
enamel on steel plates
80 plates
51 x 259
Burroughs Wellcome Collection of
American Contemporary Art

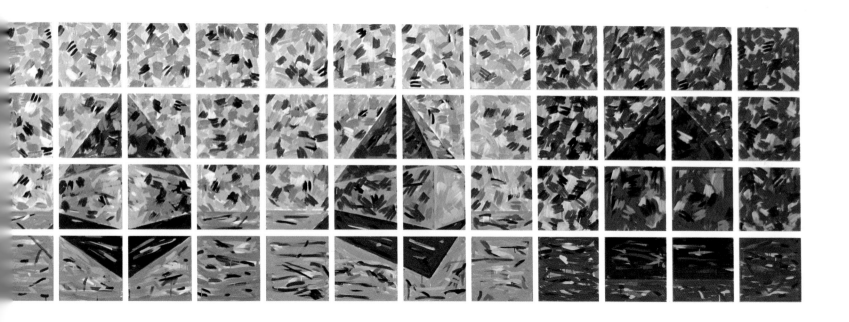

27 *Howard Street/Day and Night* 1977
baked enamel and silkscreen grid,
enamel on steel plates
96 plates
155 x 103
Collection Paul and Camille Oliver
Hoffman

(opposite)
Termino Avenue 1977
baked enamel and silkscreen grid,
enamel on steel plates
96 plates
77 x 207
Collection Mr. and Mrs. Robert Meltzer

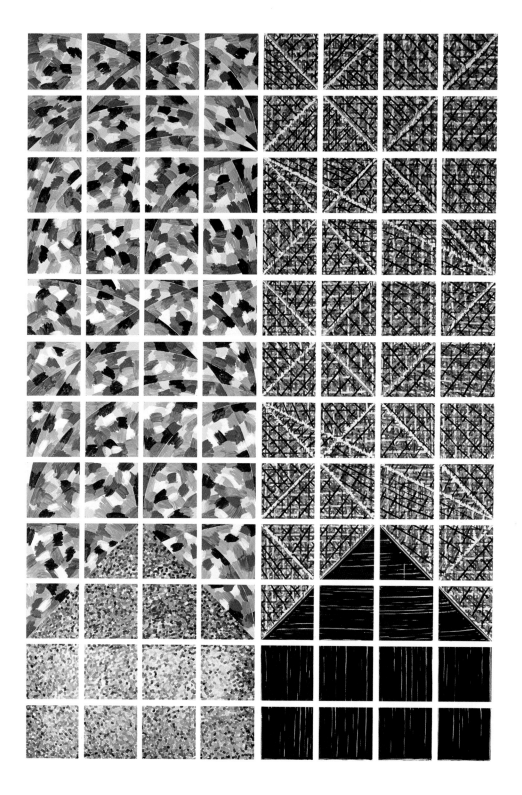

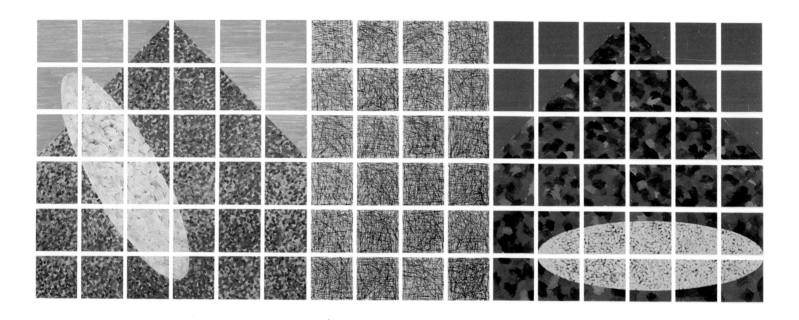

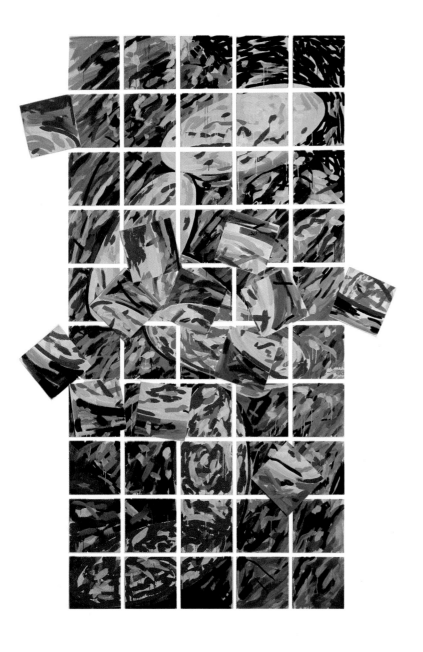

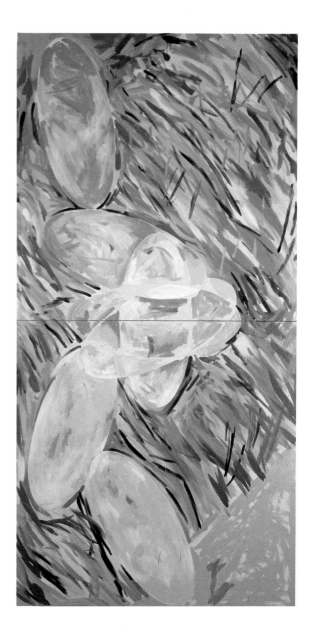

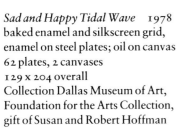

Sad and Happy Tidal Wave 1978
baked enamel and silkscreen grid,
enamel on steel plates; oil on canvas
62 plates, 2 canvases
129 x 204 overall
Collection Dallas Museum of Art,
Foundation for the Arts Collection,
gift of Susan and Robert Hoffman

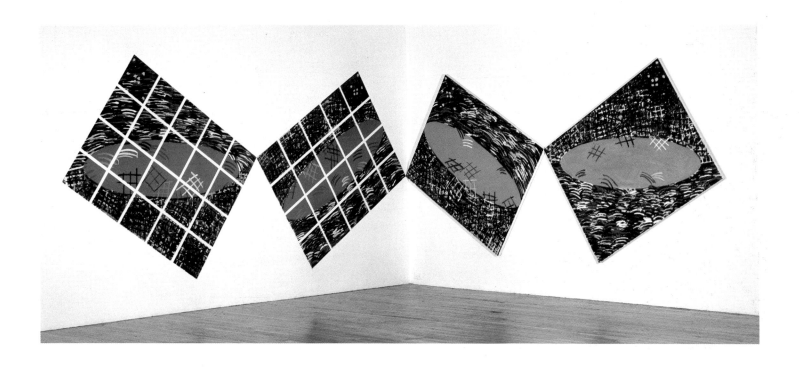

Swimmer Lost at Night (for Tom Hess) 1978
baked enamel and silkscreen grid, enamel
on steel plates; oil on canvas
40 plates, 2 canvases
78 x 317 overall
Collection The Museum of Modern Art,
Mrs. George Hamlin Shaw Fund

Sunrise, Sunset II 1979
baked enamel and silkscreen grid,
enamel on steel plates;
oil on canvas
36 plates, 5 canvases
c. 144 x 144
Collection the artist

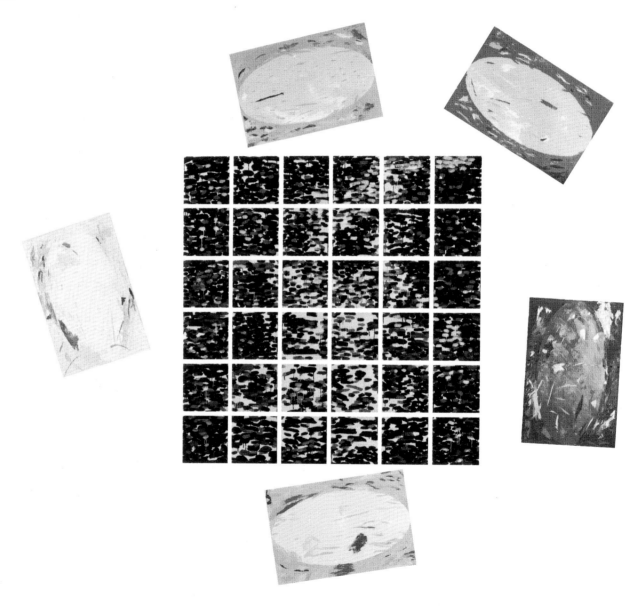

Water at Sunset,
Swimmers at Sunrise 1979
oil on canvas; baked enamel and
silkscreen grid,
enamel on steel plates
30 plates, 1 canvas
c. 144 x 144 overall
Collection Paula Cooper

Swimmers and Rafts, Ellipse 1979
baked enamel and silkscreen grid,
enamel on steel plates; oil on canvas
40 plates, 1 canvas
240 x 77 overall
Collection the artist

In 1980, Bartlett began three series of seven paintings each, again on the *In the Garden* theme. In each series, she used four different media and four different supports. The first painting is always composed of four parts, one in each of the four media; the other six are diptychs in varying pairs of media. Works in the first series, done in predominantly brown tones, are titled *In the Garden 1-7*; the second and third series are titled *In the Garden II, 1-7* and *In the Garden III, 1-7*, respectively.

 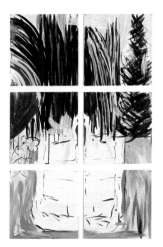 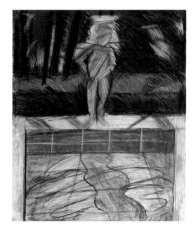 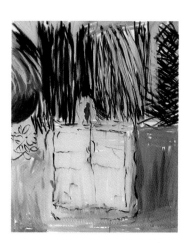

In the Garden 1 1980
Collection William J. Hokin

oil on canvas
36 x 30

baked enamel and silkscreen grid,
enamel on steel plates
6 plates
38 x 25

conte crayon on paper under glass
36 x 30

enamel on glass
36 x 30

In the Garden II, 5 1981
baked enamel and silkscreen grid,
enamel on steel plates; conte crayon on paper
with glass
12 plates, 1 sheet
51 x 74 overall
Collection Joslyn Art Museum

In the Garden II, 6 1981
enamel on glass; baked enamel and
silkscreen grid,
enamel on steel plates
12 plates
51 x 74
Collection Albright-Knox Art Gallery
Edmund Hayes Fund, 1982

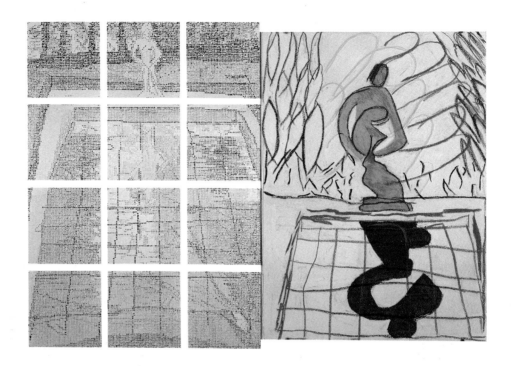

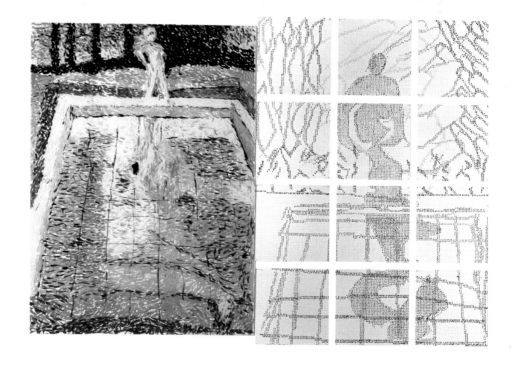

In the Garden III, 3 1982
oil on canvas; gouache on paper under glass
1 canvas, 1 sheet
60 x 96 overall
Collection Jane and Gerald Katcher

In the Garden III, 7 1982
enamel on glass; conte on paper under glass
60 x 96 overall
Collection of Mr. and Mrs. Terry Goodrich

In the Garden 118 1982
oil on 2 canvases
84 x 144
Collection David Meitus

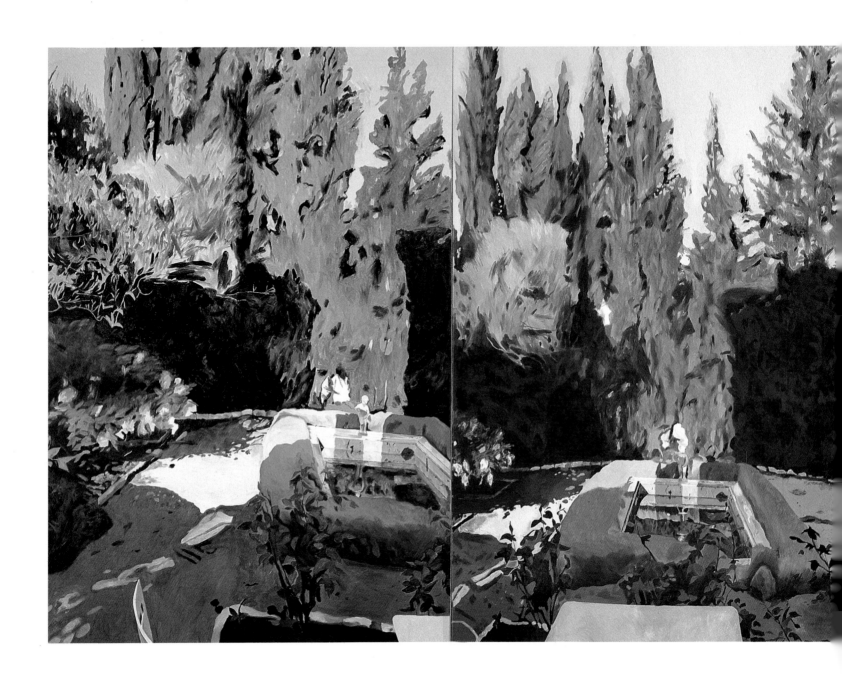

Shadow 1983
oil on 4 canvases
84 x 240
Collection The Chase Manhattan Bank, N.A.

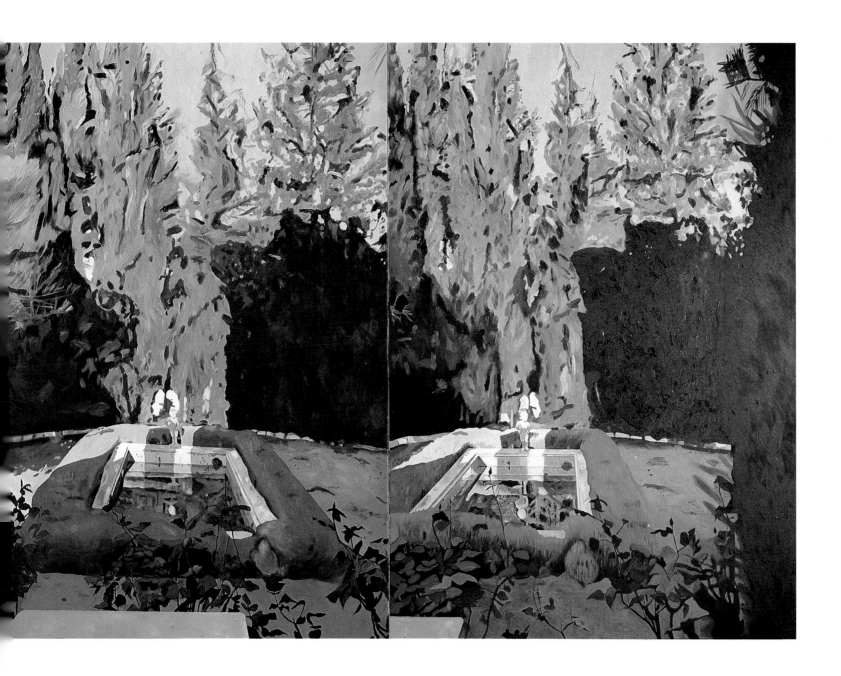

Exhibition History

1970 INDIVIDUAL
119 Spring Street (Alan Saret's loft), New York.

1972 INDIVIDUAL
Reese Palley Gallery, New York.

1972 GROUP
1972 Annual Exhibition. Whitney Museum of American Art, New York. Exhibition catalogue, foreword by John I.H. Baur.
Annual Invitational: Focus on Women. Kent State University, Ohio.
Painting & Sculpture Today 1972. Indianapolis Museum of Art. Exhibition catalogue, foreword by Carl J. Weinhardt, Jr., introduction by Richard L. Warrum.
Art Without Limits. Rochester Memorial Art Gallery, New York.
Painting: New Options. Walker Art Center, Minneapolis. Exhibition catalogue, introduction by Dean Swanson, essay by Philip Larson.
American Women Artists. Kunsthaus, Hamburg, Germany.
Small Series. Paula Cooper Gallery, New York.

1973 GROUP
Jennifer Bartlett/Jack Tworkov. Jacob's Ladder, Washington, D.C.
Art in Evolution. Xerox Exhibition Center, Rochester, New York. Exhibition catalogue, essay by John Sorce.
Group Exhibition. Paula Cooper Gallery, New York.
Contemporary American Drawings. Whitney Museum of American Art, New York.
C.7500. California Institute of Art, Valencia, California. Traveled to Wadsworth Atheneum, Hartford, Connecticut; Moore College of Art, Philadelphia; Institute of Contemporary Art, Boston; Walker Art Center, Minneapolis; Smith College Museum of Art, Northampton, Massachusetts. Exhibition catalogue, essay by Lucy R. Lippard.

Works on Paper. Tyler School of Art, Philadelphia.
Conceptual Art. Women's Interart Center, New York.
Drawing and Other Work. Paula Cooper Gallery, New York.

1974 INDIVIDUAL
Paula Cooper Gallery, New York.
Saman Gallery, Genoa, Italy.

1974 GROUP
Spring Group Exhibition. Paula Cooper Gallery, New York.
Fall Group Exhibition. Paula Cooper Gallery, New York.
Works on Paper. Virginia Museum of Fine Arts, Richmond. Exhibition catalogue, foreword by James M. Brown.
Opening Group Exhibition. Doyle-Pigman Gallery, Paris, France.
Drawings and Other Work. Paula Cooper Gallery, New York.

1975 INDIVIDUAL
John Doyle Gallery, Chicago.

1975 GROUP
The 34th Biennial Exhibition of Contemporary Art. Corcoran Gallery of Art, Washington, D.C. Exhibition catalogue, introduction by Roy Slade.
34th Exhibition: Society of Contemporary Art — The Small Scale in Contemporary Art. The Art Institute of Chicago. Exhibition brochure, introduction by Peter Frank.
Jennifer Bartlett and Joel Shapiro. The Garage, London.
9e Biennale de Paris. Exhibition catalogue, foreword by Pontus Hulten, essays by Georges Boudaille, Gunter Metken, Lucy R. Lippard, Douglas Davis, statement on Jennifer Bartlett by Jack Tworkov.
Recent Work. Middlebury College, Middlebury, Vermont.
Approaching Painting: Part One. Hallwalls, Buffalo, New York.

1976 INDIVIDUAL
Rhapsody. Paula Cooper Gallery, New York. Traveled to Hood Museum of Art, Dartmouth College, Hanover, New Hampshire; Contemporary Arts Center, Cincinnati; Wadsworth Atheneum, Hartford, Connecticut (brochure); University of California, Irvine; San Francisco Museum of Art; Art Museum of South Texas, Corpus Christi; Baltimore Museum of Art.

1976 GROUP
Group Exhibition. Paula Cooper Gallery, New York.
Scale. Fine Arts Building, New York.
72nd American Exhibition. The Art Institute of Chicago. Exhibition catalogue, introduction by A. James Speyer, essay by Anne Rorimer.
The Liberation: Fourteen Women Artists. Aarhus Kunstmuseum, Denmark. Traveled to Galerie Asboek, Copenhagen. Exhibition catalogue, foreword by Kristian Jakobsen, introduction by Charlotte Christensen, essay by Jane Livingston.
Group Exhibition. Paula Cooper Gallery, New York.
Contemporary Approaches to Painting. The University Art Galleries, University of California, Santa Barbara.
New York — Downtown Manhattan: Soho. Akademie der Künste and Berliner Festwochen, West Berlin. Traveled to Louisiana Museum, Humlebaek, Denmark. Exhibition catalogue, foreword by Rene Block and Stephen Koch, essays by Lawrence Alloway, Peter Frank, Lucy R. Lippard, Douglas Davis, Stephen B. Reichard and Joan LaBarbara.
New Work/New York. California State University, Los Angeles. Exhibition catalogue, foreword by Daniel Douke, essay by Michael Auping.
Group Exhibition. Galerie Mukai, Tokyo.
Yale Art Students' Choice 1976-77. Yale University School of Art Gallery, New Haven.
Die reine Form von Malewitsch bis Albers. Kunstmuseum, Düsseldorf, West Germany. Exhibition catalogue, foreword by Wend von Kalnein.

1977 GROUP

Group Exhibition. Paula Cooper Gallery, New York.

Private Images: Photographs by Painters. Los Angeles County Museum of Art.

1977 Biennial Exhibition. Whitney Museum of American Art, New York. Exhibition catalogue, foreword by Tom Armstrong, introduction by Barbara Haskell, Patterson Sims, Marcia Tucker.

Painting 75, 76, 77. Sarah Lawrence College, Bronxville, New York. Traveled to The American Foundation for the Arts, Miami; The Contemporary Arts Center, Cincinnati. Exhibition catalogue, essay by Eva Skrande.

For the Mind and the Eye: Art Work by Nine Americans. New Jersey State Museum, Trenton.

Documenta 6. Kassel, West Germany. Exhibition catalogue, volume I: "Malerei, Plastik, Performance." Essay by Andrea Miller-Keller.

Group Exhibition. Paula Cooper Gallery, New York.

Historical Aspects of Constructivism and Concrete Art. Musée d'Art Moderne de la Ville de Paris. Exhibition catalogue, essays by Willy Rotzler, Celia Ascher, Otto Hahn and Gladys Fabre.

New York: The State of Art. New York State Museum, Albany.

Critics' Choice. The Joe and Emily Lowe Art Gallery, Syracuse University, Syracuse, New York. Traveled to Munson-Williams-Proctor Institute, Utica, New York. Exhibition brochure, foreword by Joseph Scala.

Master Drawings and Prints. The New Gallery, Cleveland, Ohio.

1978 INDIVIDUAL

Saman Gallery, Genoa, Italy.

Hansen-Fuller Gallery, San Francisco.

1978 GROUP

Group Exhibition. Paula Cooper Gallery, New York.

New York 1977. Mead Gallery, Amherst College, Amherst, Massachusetts.

Tenth Anniversary Group Exhibition. Paula Cooper Gallery, New York.

Prints in Cincinnati Collections. Contemporary Arts Center, Cincinnati.

New Image Painting. Whitney Museum of American Art, New York. Exhibition catalogue, introduction by Richard Marshall.

Point. Philadelphia College of Art, Pennsylvania. Exhibition catalogue, essay by Janet Kardon.

Selected Prints II. Brooke Alexander, Inc., New York. Exhibition catalogue.

1979 INDIVIDUAL

Margo Leavin Gallery, Los Angeles.

The Clocktower, New York.

University of Akron, Ohio.

Carleton College, Northfield, Minnesota.

Heath Gallery, Atlanta.

Paula Cooper Gallery, New York.

1979 GROUP

1979 Biennial Exhibition. Whitney Museum of American Art, New York. Exhibition catalogue, preface by Tom Armstrong; foreword by John G. Hanhardt, Barbara Haskell, Richard Marshall, Mark Segal, and Patterson Sims.

Two Decades of Abstraction. University of South Florida Art Galleries, Tampa, Florida. Exhibition catalogue, essay by Margaret A. Miller.

Drawings about Drawings, New Directions in the Medium (1968-1978), William Hayes Ackland Memorial Art Center, University of North Carolina, Chapel Hill.

Small is Beautiful. Freedman Art Gallery, Albright College, Reading, Pennsylvania. Exhibition catalogue, introduction by Robert H. Frankel.

New York Now. Phoenix Art Museum. Exhibition catalogue, introduction by Robert H. Frankel.

Decade in Review. Whitney Museum of American Art, New York. Exhibition brochure, essay by Patterson Sims.

Corners. Hayden Gallery, Massachusetts Institute of Technology, Cambridge, Massachusetts. Exhibition catalogue, essay by Kathy Halbreich.

Art on Paper 1979. University of North Carolina, Weatherspoon Art Gallery, Chapel Hill. Exhibition catalogue, foreword by James E. Tucker.

20th Century Recent Acquisitions. The Metropolitan Museum of Art, New York.

1980 INDIVIDUAL

Galerie Mukai, Tokyo.

Akron Art Institute, Ohio.

The Albright-Knox Art Gallery and Hallwalls, Buffalo, New York. Exhibition catalogue, introduction and essay by Charlotta Kotik.

1980 GROUP

Extensions: Jennifer Bartlett, Lynda Benglis, Robert Longo, Judy Pfaff. Contemporary Arts Museum, Houston. Exhibition catalogue, introduction by Linda L. Cathcart.

Urban Encounters. Institute of Contemporary Art, University of Pennsylvania, Philadelphia. Exhibition catalogue, essays by Janet Kardon, Lawrence Alloway, Ian L. McHarg, Nancy Foote.

Printed Art: A View of Two Decades. The Museum of Modern Art, New York. Exhibition catalogue, essay by Riva Castleman.

Selections from a Colorado Collection. University of Colorado Art Galleries, Boulder.

Pictures for an Exhibition. The Whitechapel Art Gallery, London.

Paula Cooper at Yvon Lambert. Galerie Yvon Lambert, Paris.

Aspects of the 70's: Painterly Abstraction. Brockton Art Center, Massachusetts. Exhibition catalogue, essay by Marilyn Friedman Hoffman.

Drawings: The Pluralist Decade. Venice Biennale, American Pavilion. Traveled to Institute of Contemporary Art, University of Pennsylvania, Philadelphia; Museum of Contemporary Art, Chicago. Exhibition catalogue, introduction by Janet Kardon, essays by John Hallmark Neff, Rosalind Krauss, Richard Lorber, Edit de Ak, John Perrault, Howard N. Fox.

Cleveland Collects Modern Art. Cleveland Museum of Art, Ohio. Exhibition catalogue, essay by Edward B. Henning.

Art in Our Time. Organized by HHK Foundation for Contemporary Art, Milwaukee. Traveled to Milwaukee Art Museum; Contemporary Art Center, Cincinnati; Columbus Museum of Art; Virginia Museum of Fine Arts, Richmond; Krannert Art Museum, University of Illinois, Champaign; High Museum of Art, Atlanta; University of Iowa Museum of Art, Iowa City; Brooks Memorial Art Gallery, Memphis; Archer M. Huntington Art Gallery, University of Texas, Austin. Exhibition catalogue, introduction by I. Michael Danoff.

1981 INDIVIDUAL
Paula Cooper Gallery, New York.
Margo Leavin Gallery, Los Angeles.

1981 GROUP
Twenty Artists: Yale School of Art 1950-70. Yale University Art Gallery, New Haven. Exhibition catalogue, preface by Alan Shestack and Andrew Forge; essay by Irving Sandler.
1981 Biennial Exhibition. Whitney Museum of American Art, New York. Exhibition catalogue, foreword by Tom Armstrong; preface by John G. Hanhardt, Barbara Haskell, Richard Marshall, Patterson Sims.
Group Exhibition. Dart Gallery, Chicago.
New Dimensions in Drawing. The Aldrich Museum of Contemporary Art, Ridgefield, Connecticut. Exhibition catalogue, introduction by Richard Anderson, essay by Dorothy Mayhall.
The R.S.M. Collection. The Contemporary Arts Center, Cincinnati. Exhibition catalogue, foreword by Robert Stearns, essay by Pat Thompson.
Landscapes in Recent Painting. Museum of Fine Arts, Springfield, Massachusetts. Exhibition catalogue, foreword by Richard C. Muhlberger, essay by Sally Yard.
Drawings. Galerie Mukai, Tokyo.
Selections from the Chase Manhattan Bank Art Collection. University Gallery, Fine Arts Center, University of Massachusetts. Exhibition catalogue, foreword by Hugh Davies, introduction by Helaine Posner.

Baroques 81. Musée d'Art Moderne de la Ville de Paris, France. Exhibition catalogue, essay by Lucien Tapie.
The American Landscape: Recent Developments. Whitney Museum of American Art, Fairfield County, Stamford, Connecticut.
Amerikanische Malerei, 1930-1980. Haus der Kunst, Munich. Exhibition catalogue, foreword by Tom Armstrong.
Druckgraphik: Wandlungen eines Mediums seit 1945. Kupferstichkabinett Berlin, Staatliche Museen, West Germany. Exhibition catalogue, foreword and introduction by Alexander Dückers.
Group Exhibition. Paula Cooper Gallery, New York.

1982 INDIVIDUAL
Joslyn Art Museum, Omaha. Exhibition catalogue, text by Holliday T. Day.
Paula Cooper Gallery, New York.
The Tate Gallery, London. Exhibition catalogue, foreword by Alan Bowness, introduction by Richard Francis.
McIntosh/Drysdale Gallery, Houston.

1982 GROUP
U.S. Art Now. Nordiska Kompaniet, Stockholm. Exhibition catalogue, introduction by Lars Peder Hedberg.
American Prints: 1960-1980. Milwaukee Art Museum. Exhibition catalogue, foreword by Gerald Nordland, essay by Verna Posever Curtis.
The R.S.M. Collection. Krannert Drawing Room, Purdue University, Lafayette, Indiana.
Group Exhibition. Galerie Mukai, Tokyo.
Big Prints. Arts Council of Great Britain, London. Exhibition catalogue, foreword by Joanna Drew, Michael Harrison; introduction by James Carey.
Selected Prints III. Brooke Alexander, Inc., New York. Exhibition catalogue.
Body Language. Hayden Gallery, Massachusetts Institute of Technology, Cambridge. Traveled to The Fort Worth Art Museum, Texas; University of South Florida Art Gallery, Tampa; Contemporary Arts Center, Cincinnati. Exhibition catalogue, essay by Roberta Smith.

Block Prints. Whitney Museum of American Art, New York. Exhibition brochure, essay by Judith Goldman.
Recent American Woodcuts. Akron Art Museum, Ohio.
Collector's Gallery XVI. McNay Art Institute, San Antonio, Texas.
Alternative Approaches to the Landscape. Thomas Segal Gallery, Boston.
Black and White — A Print Survey. Castelli Graphics, New York.

1983 INDIVIDUAL
Margo Leavin Gallery, Los Angeles.
Gloria Luria Gallery, Bay Harbor Island, Florida.
Heath Gallery, Atlanta.
Paula Cooper Gallery, New York.

1983 GROUP
RSM: Selections from a Contemporary Collection. Herron School of Art, Indiana University-Purdue University at Indianapolis. Exhibition catalogue, essay by Martha Winans.
Recent Acquisitions. The Museum of Modern Art, New York.
Back to the USA. Rheinisches Landesmuseum Bonn. Traveled to Kunstmuseum Luzern, Lucerne, Switzerland; Württembergischer Kunstverein, Stuttgart. Exhibition catalogue, foreword by Martin Kunz, Cristoph B. Ruger, Tilman Osterwold; essays by Klaus Honnef and Gabriele Honnef-Harling.
Black and White. Margo Leavin Gallery, Los Angeles.
Perspectives of Landscape. Fuller Goldeen Gallery, San Francisco.
Prints from Blocks: Gauguin to Now. The Museum of Modern Art, New York. Exhibition catalogue, essay by Riva Castleman.
Minimalism to Expressionism: Painting and Sculpture Since 1965 from the Permanent Collection. Whitney Museum of American Art, New York. Exhibition brochure, text by Patterson Sims.
Contemporary Drawings. Barbara Krakow Gallery, Boston.

The American Artist as Printmaker: 23rd National Print Exhibition. The Brooklyn Museum, New York. Exhibition catalogue, foreword by Robert T. Buck, text by Barry Walker.

1984 Olympic Fine Art Posters: 15 Contemporary Artists Celebrate the Games of the XXIIIrd Olympiad. University Art Gallery, California State University Dominguez Hills, California.

The Figurative Mode: Recent Drawings from New York City Galleries. Ruth E. Dowd Fine Arts Center Gallery, State University of New York, Cortland, New York.

A Changing Group Exhibition. Paula Cooper Gallery, New York.

Work by Newly Elected Members and Recipients of Honors and Awards. American Academy and Institute of Arts and Letters, New York. Exhibition brochure.

1984 INDIVIDUAL
Rose Art Museum, Brandeis University, Waltham, Massachusetts. Exhibition catalogue, text by Nancy Miller.

Long Beach Museum of Art, Long Beach, California.

Matrix/Berkeley 73. University Art Museum, University of California, Berkeley. Exhibition brochure, essay by Constance Lewallen.

1984 GROUP
New American Painting: A Tribute to James and Mari Michener. Archer M. Huntington Art Gallery, University of Texas, Austin. Exhibition catalogue, foreword by Eric McCready.

Nature As Image. Organization of Independent Artists, Inc., Directions on Broadway Gallery, New York. Exhibition catalogue, essay by Philip Verre.

American Women Artists Part II: The Recent Generation. Sidney Janis Gallery, New York. Exhibition catalogue.

Reflections: New Conceptions of Nature. Hillwood Art Gallery, Long Island University, C.W. Post Campus, Brookville, New York. Exhibition catalogue, essay by Judy K. Collischan Van Wagner.

Parasol and Simca: Two Presses/Two Processes. The Center Gallery, Bucknell University, Lewisburg, Pennsylvania. Traveled to Sordoni Art Gallery, Wilkes College, Wilkes-Barre, Pennsylvania. Exhibition catalogue, foreword by Joseph Jacobs, essay by Lizbeth Marano.

Reflections of Nature — Flowers in American Art. Whitney Museum of American Art, New York. Exhibition catalogue, foreword by Tom Armstrong, introduction by Barbara Novak, essay by Ella M. Foshay.

Prints from the Collection of Lois and Michael Torf. Williams College Museum of Art. Traveled to Museum of Fine Arts, Boston. Exhibition catalogue, foreword by Jan Fontein, Thomas Krens; essays by Clifford Ackley, Thomas Krens, Deborah Meneker.

American Art Since 1970. Organized by Whitney Museum of American Art, New York. Traveled to La Jolla Museum of Contemporary Art; North Carolina Museum of Art, Raleigh; Sheldon Memorial Art Gallery, University of Nebraska, Lincoln; Center for the Fine Arts, Miami. Exhibition catalogue, foreword by Tom Armstrong, introduction by Richard Marshall.

New Vistas: Contemporary American Landscapes. The Hudson River Museum, Yonkers, New York. Traveled to Tuscon Museum of Art. Exhibition catalogue, foreword by R. Andrew Maass, Rick Beard, introduction by Janice C. Oresman.

Correspondences. LaForet Museum, Tokyo. Exhibition catalogue, essay by Nicholas A. Moufarrege.

Drawings. Gillespie-Laage-Salomon, Paris.

Contemporary Drawings: Concepts, Records, Projects. Sarah Lawrence College, Bronxville, New York. Exhibition catalogue, essay by Joseph Forte.

1985 INDIVIDUAL
Lowe Art Museum, Coral Gables, Florida.

1985 GROUP
Contemporary Prints: The Working Process. Whitney Museum of Art, Fairfield County, Stamford, Connecticut. Exhibition brochure, essay by Pam Gruninger.

A New Beginning: 1968-1978. The Hudson River Museum, Yonkers, New York. Exhibition catalogue, introduction by Rick Beard, essay by Mary Delahoyd.

Bibliography

Articles and Reviews

1971

Davis, Douglas. "The Invisible Woman Is Visible," *Newsweek*, November 15, 1971, pp. 130-131.

1972

Anderson, Laurie. "Reviews and Previews," *Art News*, 70 (February 1972), p. 12.

Ratcliff, Carter. "New York Letter," *Art International*, 16 (March 20, 1972), p. 32.

Shirey, David L. "Jennifer Bartlett," *The New York Times*, January 22, 1972, section 2, p. 24.

1973

Crimp, Douglas. "New York Letter," *Art International*, 17 (March 1973), p. 41.

1974

Alloway, Lawrence. "Review," *Artforum*, 12 (May 1974), p. 64.

"Diaristic Art: A Trek through the Navelocentric Universe," *Art-Rite*, 5 (Spring 1974), p. 9.

Lubell, Ellen. "Arts Reviews," *Arts Magazine*, 48 (May 1974), p. 59.

_____ . "Arts Reviews," *Arts Magazine*, 49 (November 1974), p. 9.

1975

Fuller, Peter. "London," *Art & Artists*, 10 (June 1975), p. 26.

Kent, Sarah. "UK Reviews," *Studio International*, 190 (July-August 1975), pp. 83-84.

1976

Bourdon, David. "Jennifer Bartlett's 'Rhapsody,'" *The Village Voice*, May 31, 1976, p. 117.

Brach, Paul. "Review," *Artforum*, 15 (October 1976), pp. 61-62.

Brown, Ellen. "988 Panels in Bartlett's Spectacular 'Rhapsody,'" *Cincinnati Post*, December 11, 1976, p. 30.

"Color Originals," *House & Garden*, 148 (September 1976), p. 86.

Findsen, Owen. "What's the Big Idea?," *Cincinnati Enquirer*, December 12, 1976, p. J7.

Glueck, Grace. "Painting a Cosmic Conversation," *The New York Times*, May 23, 1976, section 2, p. 35.

Lubell, Ellen. "Arts Reviews," *Arts Magazine*, 51 (September 1976), pp. 19-20.

Rush, David. "Paintings with a Sculptural Character," *Artweek*, October 30, 1976, pp. 1,16.

Russell, John. "On Finding a Bold New Work," *The New York Times*, May 19, 1976, section 2, p. 1, 31.

Seldin, Henry. "East Coast Meets West in New Work/New York," *Los Angeles Times*, October 24, 1976, p. 92.

Shapiro, Lindsay Stamm. "Review of Exhibitions: New York," *Art in America*, 64 (September-October 1976), pp. 105-106.

Webster, Sally. "Jennifer Bartlett," *The Feminist Art Journal*, 5 (Fall 1976), pp. 37-38.

Wooster, Ann-Sargent. "New York Reviews," *Art News*, 75 (September 1976), pp. 124-125.

1977

Frank, Peter. "Pictures as an Exhibition," *The Village Voice*, November 7, 1977, p. 75.

Henry, Gerrit. "New York Reviews," *Art News*, 76 (December 1977), p. 140.

Hess, Thomas B. "Ceremonies of Measurement," *New York Magazine*, March 21, 1977, pp. 60-62.

Lubell, Ellen. "Arts Reviews," *Arts Magazine*, 52 (December 1977), pp. 20-30.

Miller-Keller, Andrea. "A New Work: 'Rhapsody,'" *Matrix*, 28 (February-March 1977).

Raynor, Vivian. "Review," *The New York Times*, October 21, 1977, p. C25.

Scanes, Simon. "An Archetypal Rhapsody, Hartford Scenes," *The Hartford Advocate*, March 9, 1977, p. 19.

Smith, Roberta. "The 1970s at the Whitney," *Art in America*, 65 (May-June 1977), pp. 91-93.

Thea, Carolee. "Review: Jennifer Bartlett," *Woman Art*, 2 (Winter 1977-78), pp. 35-36.

1978

Drewes, Caroline. "Jennifer Bartlett: Artist Who Keeps Pushing," *San Francisco Examiner*, May 24, 1978, p. 24.

Foster, Hal. "Reviews: New York," *Artforum*, 16 (January 1978), p. 67.

Muchnic, Suzanne. "Jennifer Bartlett's 'Rhapsody,'" *Artweek*, February 25, 1978, pp. 1, 16.

"Prints and Photographs Published," *The Print Collector's Newsletter*, 9 (July-August 1978), pp. 89-90.

1979

Ashberry, John. "Climbing the Wallpaper," *New York Magazine*, January 24, 1979, pp. 103-104.

Boorsch, Suzanne. "New Editions," *Art News*, 78 (March 1979), p. 42.

Brody, Jacqueline. "New Prints of Worth: A Question of Taste," *The Print Collector's Newsletter*, 10 (September-October 1979), pp. 109-119.

Foster, Hal. "Reviews: New York," *Artforum*, 18 (December 1979), pp. 69-70.

Gibson, Eric. "New York Letter," *Art International*, 22 (March 1979), p. 45.

Hess, Thomas B. "Les Nouvelle Images de la Peinture Américaine," *Art Press Internationale*, 23 (May 1979), pp. 6-7.

King, Mary. "New Gallery's Show: Refreshing Variety," *St. Louis Dispatch*, December 27, 1979, p. 4E.

Madans, Christina J. "Dialogues of Form and Feeling," *Artweek*, January 13, 1979, p. 6.

Moran, Barbara, and Steve Johnson. "Artwork Debuts at Russell Building," *The Atlanta Constitution*, December 11, 1979, p. C1.

"Prints and Photographs Published," *The Print Collector's Newsletter*, 10 (July-August 1979), p. 92.

Russell, John. "Art People," *The New York Times*, September 7, 1979, p. C14.

_____ . "Art: Figures in American Painting," *The New York Times*, November 9, 1979, p. C23.

Salle, David. "New Image Painting," *Flash Art*, March-April 1979, pp. 40-41.

Smith, Roberta. "The Abstract Image," *Art in America*, 67 (March-April 1979), pp. 102-105.

———. "Bartlett's Swimmers," *Art in America*, 67 (November, 1979), pp. Cover, 93-97.

Taylor, Robert. "Do Corners Have Intrinsic Value?" *Boston Sunday Globe*, October 7, 1979, p. D2.

Wortz, Melinda. "Los Angeles," *Art News*, 78 (March 1979), pp. 147, 150.

1980

Bertolo, Diane. "Bartlett and Morton, from a Position of Strength: Ideas on Women's Art," *The Buffalo News*, November 16, 1980, p. F2.

———. "Adding Up Jennifer Bartlett," *Buffalo Evening News*, November 30, 1980, p. F2.

Crossley, Mimi. "Review: Extensions," *Houston Post*, January 25, 1980, section E, pp. 1, 5.

Danoff, I. Michael. "Jennifer Bartlett Paintings," *Dialogue*, September-October 1980, p. 54.

Fujieda, Akio. "Jennifer Bartlett Exhibition," *Bijutsu Techo*, 32 (August 1980), pp. 210-229.

Huntington, Richard. "Jennifer Bartlett's Paintings Offer Hidden Narrative," *Courier Express*, November 21, 1980, p. 13.

Kalil, Susie. "Issues in Extension," *Artweek*, February 9, 1980, pp. 1, 16.

Perrone, Jeff. "Ten Best/Ten Worst New York, 1979-1980," *Images and Issues*, 1 (Winter 1980-81), pp. 22-26.

Rickey, Carrie. "Reviews: New York," *Artforum*, 18 (January 1980), pp. 69-70.

———. "Jennifer Bartlett, Paula Cooper," *Flash Art*, January-February 1980, p. 33.

Russell, John. "Art: Two Decades of Ubiquitous Prints," *The New York Times*, February 15, 1980, p. C22.

Schreiber, Barbara. "Jennifer Bartlett's 'Swimmer's Atlanta,'" *Atlanta Art Workers Coalition Newspaper*, 4 (January-February 1980), p. 8.

Tennant, Donna. "Four Artists in Struggle for Originality," *Houston Chronicle*, January 27, 1980, pp. 15, 29.

1981

Amaya, Mario. "Artist's Dialogue: A Conversation with Jennifer Bartlett," *Architectural Digest*, 38 (December 1981), pp. 50, 54, 56, 58, 60.

Deitcher, David. "Review of Exhibitions, New York," *Art in America*, 69 (April 1981), p. 146.

Flood, Richard. "Reviews: New York," *Artforum*, 19 (April 1981), p. 67.

Glueck, Grace. "Art: Garden Drawings by Jennifer Bartlett," *The New York Times*, January 23, 1981, p. C19.

Karson, Robin. "Art," *The Daily News*, July 23, 1981, Weekend Section, pp. W1, W8.

Lawson, Thomas. "Flash Art Reviews: New York," *Flash Art*, March-April 1981, p. 39.

Levin, Kim. "Bartlett's Pairs," *The Village Voice*, February 4, 1981, p. 79.

Millet, Catherine, and Germano Celant. "Baroques '81, les débordements d'une avant-garde internationale," *Art Press*, 52 (October 1981), pp. 4-11.

Perrone, Jeff. "She's Got Style," *Arts Magazine*, 55 (April 1981), pp. 160-163.

Phillips, Deborah C. "New Editions," *Art News*, 80 (September 1981), pp. 158-159.

"Prints and Photographs Published," *The Print Collector's Newsletter*, 11 (January-February 1981), p. 209.

Russell, John. "How the Arts Mirror the Retreat of Manhood," *The New York Times*, February 1, 1981, section 2, pp. 1, 12.

Smith, Roberta. "Biennial Blues," *Art in America*, 69 (April 1981), pp. 92-101.

Southand, Edna Carter. "A Seventies Selection: Works from the Whitney," *Dialogue*, 3 (March-April 1981), p. 55.

Tatransky, Valentine. "New Work in New York," *Museum Magazine*, 2 (July-August 1981), pp. 64-68.

1982

Field, Richard S. "On Recent Woodcuts," *The Print Collector's Newsletter*, 13 (March-April 1982), pp. 1-6.

Friedman, Jon R. "Arts Reviews," *Arts Magazine*, 57 (September 1982), pp. 40-41.

Gardner, Paul. "Will Success Spoil Bob and Jim, Louise and Larry?" *Art News*, 81 (November 1982), pp. 102-109.

Glueck, Grace. "Art: After Two Years, 'Selected Prints III,'" *The New York Times*, September 24, 1982, p. C21.

Goldman, Judith. "Woodcuts: A Revival," *Portfolio*, 4 (November-December 1982), pp. 66-71.

Howe, Katherine. "Jennifer Bartlett at Paula Cooper," *Flash Art*, September-October 1982, p. 68.

Johnson, Patricia. "Roots in Nature, but Souls in Magic," *The Houston Chronicle*, November 14, 1982, p. 68.

Kalil, Susie. "In the Galleries — Tracy, Bartlett, Fridge, Hollis," *Houston Post*, November 28, 1982, p. 9F-10F.

Kitchen, Paddy. "Van Dyke's Royal Class," *The Times* (London), November 23, 1982, p. 8.

Larson, Kay. "Formal Funk," *New York Magazine*, June 7, 1982, pp. 74-75.

Linker, Kate. "Reviews: New York," *Artforum*, 21 (October 1982), p. 69.

"Literature and the Arts," *Wall Street Journal*, December 17, 1982, p. 17.

Phillips, Deborah C. "Looking for Relief? Woodcuts Are Back," *Art News*, 81 (April 1982), pp. 92-96.

Russell, John. "Jennifer Bartlett Creates an Archetypal New Found Land," *The New York Times*, May 23, 1982, section 2, p. 35.

Smith, Roberta. "Bartlett's Unfamiliar Quotations," *The Village Voice*, May 25, 1982, p. 88.

1983

Bernier, Rosamund. "Garden of the Mind," *House & Garden*, 155 (May 1983), pp. 128-133, 190, 192.

Brenson, Michael. "Jennifer Bartlett: Recent Paintings," *The New York Times*, October 7, 1983, p. C25.

Collier, Caroline. "Flash Art Reviews: London," *Flash Art*, May 1983, pp. 68, 70.

Hughes, Robert. "Revelations in a Dank Garden," *Time*, October 31, 1983, p. 106.

"Jennifer Bartlett," *Bijutsu Techo*, 35 (November 1983), pp. 194-207.

Larson, Kay. "Pop Goes Colossal," *New York Magazine*, October 24, 1983, pp. 112-114.

Perlman, Meg. "New Editions," *Art News*, 82 (October 1983), p. 90.

Perrone, Jeff. "Jennifer Bartlett: New Paintings," *Arts Magazine*, 58 (December 1983), pp. 68-69.

"Prints and Photographs Published," *The Print Collector's Newsletter*, 13 (January-February 1983), pp. 216-217.

"Prints and Photographs Published," *The Print Collector's Newsletter*, 14 (September-October 1983), p. 142.

Robertson, Nan. "In the Garden with Jennifer Bartlett," *Art News*, 82 (November 1983), pp. 72-77.

Rosenthal, Mark. "The Structured Subject in Contemporary Art: Reflections on Works in the Twentieth-Century Galleries," *Bulletin* (Philadelphia Museum of Art), 79 (Fall 1983), p. 17.

Russell, John. "Journeying Back in Time at, Yes, the Whitney," *The New York Times*, June 19, 1983, section 2, p. 35.

_____ . "It's Not 'Women's Art,' It's Good Art," *The New York Times*, July 24, 1983, section 2, pp. 1, 25.

Shone, Richard. "Arte Italiana and Other London exhibitions," *Burlington Magazine*, 125 (January 1983), pp. 47-48.

Smith, Roberta. "Photos and Realism," *The Village Voice*, November 1, 1983, p. 95.

Wilson, William. "The Galleries," *Los Angeles Times*, January 21, 1983, p. 10.

1984

Blumberg, Mark. "Exhibitions: Bartlett at the Beach," *Artweek*, February 25, 1984, p. 4.

Concannon, Kevin. "Regional Reviews, Massachusetts," *Art New England*, 5 (March 1984), p. 11.

Field, Richard S. "Jennifer Bartlett: Prints, 1978-1983," *The Print Collector's Newsletter*, 15 (March-April 1984), pp. 1-6.

Gottlieb, Shirle. "Local Artists Are Featured at Long Beach Museum of Art," *Press-Telegram* (Long Beach, California), January 20, 1984, Weekend, p. 8.

_____ . "Artist Remembers Early Years in L.B." *Press-Telegram* (Long Beach, California), February 20, 1984, Life/Style, p. B3.

_____ . "Exhibit Takes Viewers Along as Participants," *Press-Telegram* (Long Beach, California), February 20, 1984, Life/Style, p. B3.

Lawson, Thomas. "Reviews, New York," *Artforum*, 22 (February 1984), pp. 80-81.

Lewallen, Constance. "Up the Creek: Ten Definitions of a Landscape," *University Art Museum Calendar* (University of California, Berkeley), June 1984, p. 2.

Muchnic, Suzanne. "Art Review: Bartlett's Images Form Variations on a Theme," *Los Angeles Times*, February 2, 1984, part 6, pp. 1, 7.

_____ . "Bartlett: Theme with Variations," *Los Angeles Times*, February 3, 1984, part 6, p. 17.

Taylor, Robert. "Astonishing Perceptions," *The Boston Globe*, January 22, 1984, pp. B1, B6.

Temin, Christine. "She Tests the Limits," *The Boston Globe*, January 22, 1984, pp. B1, B7.

Zimmer, William. "Two Shows: Munch, 'Working Drawings,'" *The New York Times*, March 4, 1984, p. 22.

Books

Russell, John. *The Meanings of Modern Art*. New York: Museum of Modern Art, 1981, p. 395, illus. p. 392.

_____ . *In the Garden*. New York: Harry N. Abrams, 1982.

Exhibition Travel Schedule

Walker Art Center
28 April to 21 July 1985

Nelson-Atkins Museum of Art
21 September to 27 October 1985

The Brooklyn Museum
18 November 1985 to 5 January 1986

La Jolla Museum of Contemporary Art
8 February to 23 March 1986

Museum of Art, Carnegie Institute
19 April to 15 June 1986

Acknowledgments

Keeping up with Jennifer Bartlett is no easy task. Her boundless energy and generous spirit have made working with her an especially exciting and rewarding experience and I am much in her debt.

Director Martin Friedman, with similar reserves of energy, was enthusiastic about this exhibition from the moment I first proposed it and his support and counsel since that time are deeply appreciated.

Numerous others have also contributed to the exhibition's organization. In particular I would like to thank Paula Cooper and Douglas Baxter, whose assistance in securing loans and photographs was indispensable to this project. Thanks are also due Elizabeth Sverbeyeff Byron, Senior Editor, *House and Garden*, for making available a number of photographs of Bartlett's work taken in Paris and Göteborg.

The staff at Walker Art Center dedicated themselves to the tasks at hand with their customarily high standards of professionalism. Several were especially helpful in the preparation of the catalogue: Robert Stearns, Director of Performing Arts and longtime admirer of Bartlett's work, reviewed my manuscript; Nancy Roth ably assisted with every aspect of the catalogue and exhibition; Fiona Irving prepared the exhibition history and bibliography with great care; Robert Jensen and the staff of the Design Department worked under tremendous pressure to produce the catalogue on deadline. I would also like to express my thanks to Roberta Smith and Calvin Tomkins for their lively and perceptive essays.

Finally, the lenders to *Jennifer Bartlett* are gratefully acknowledged. There would be no exhibition without their enormous generosity.

Marge Goldwater

Lenders to the Exhibition

Brooke and Carolyn Alexander
Allen Memorial Art Museum, Oberlin College
Amerada Hess Corporation
Mr. and Mrs. Harry W. Anderson Collection
Mr. and Mrs. Paul Anka
Sue and Steven Antebi
BankAmerica Corporation Art Collection, San Francisco
Jennifer Bartlett
Douglas Baxter
Dr. and Mrs. Peter W. Broido
The Chase Manhattan Bank, N.A.
Penny Cooper and Rena Rosenwasser
Richard and Peggy Danziger
Edward R. Downe, Jr.
Max Gordon
Mr. and Mrs. Henry R. Hamman
Helen Elizabeth Hill Trust
Robert K. Hoffman
Paul and Camille Oliver Hoffmann
William J. Hokin
Joslyn Art Museum
Mr. and Mrs. Aron B. Katz
Richard Kramer
Irit Krygier
Long Beach Museum of Art
McIntosh/Drysdale Gallery
Mr. and Mrs. Robert Meltzer
The Metropolitan Museum of Art
National Museum of American Art, Smithsonian Institution
The Nelson-Atkins Museum of Art
Neuberger Museum, State University of New York at Purchase
Paula Cooper Gallery
The Prudential Insurance Company of America
Charles and Margaret Rosenquist
Saatchi Collection, London
Dr. and Mrs. Larry Saliterman
Schloss Collection
Sidney Singer
Speyer Family Collection
Mr. and Mrs. C. Humbert Tinsman
Councilman Joel Wachs
Mr. and Mrs. Walter L. Weisman
Whitney Museum of American Art
Sue and David Workman
Two Private Collections

**Walker Art Center
Staff for the Exhibition**

Director
Martin Friedman

Administration
Donald C. Borrman

Exhibition Curator
Marge Goldwater

Curatorial Interns
Fiona Irving
Nancy Roth

Registration and Shipping
Carolyn Clark DeCato
Jane Falk

Publication Design
Robert Jensen
Henry Kugeler

Publication Editor
Elizabeth Holland

*Editorial and
Secretarial Assistance*
Linda Krenzin
Helen Slater
Christine Thoma

Typesetting
Lucinda Gardner
Debbie Sjostrom

Education
Adam Weinberg
Margy Ligon
Susan Rotilie

Public Relations
Mary Abbe Martin
Karen Statler
Lisa Hartwig

Slide Tape Production
Charles Helm
Elizabeth Josheff
Nancy Roth

Photography
Glenn Halvorson
Peter Latner

Installation
Hugh Jacobson
Mark Kramer
Mary Cutshall
David Dick
Steve Ecklund
Bradley Hudson
Joe Janson
Earl Kendall
David Lee
Owen Osten
Cody Riddle
John Snyder

Index of Illustrations

Atlantic and Pacific, AT&T: p. 129
At Sea: p. 61
At Sea, Japan (drawing): p. 96 and cover
At Sea, Japan (painting): pp. 97, 98-100
At the Lake: p. 58
At the Lake, Morning: p. 57
At the Lake, Night: p. 59
Binary Combinations: p. 38
Boy: p. 6
Chicken Tracks: p. 18
Color Index I: p. 140
Continental Drift: p. 18
Creek: pp. 76-77
Creek series: p. 77
Dog and Cat: p. 67
Drawing and Painting: p. 8
Edge Lift: p. 19
Enclosure Drift: p. 19
*Falcon Avenue, Seaside Walk, Dwight Street,
Jarvis Street, Greene Street:* pp. 52-53
Graceland Mansion: pp. 30-31
House: p. 73
House Piece: pp. 44-46
In the Garden drawings, installation views:
pp. 34
In the Garden 64 (drawing): p. 35
In the Garden 1 (painting): p. 152
In the Garden II, 5: p. 153
In the Garden II, 6: p. 153
In the Garden III, 3: p. 154
In the Garden III, 7: p. 154
In the Garden 118: p. 155
In the Garden 200: p. 65
In the Garden (Institute for Scientific
Information commission): pp. 105, 106,
107, 110-112

Nest: p. 18
Nine-Point Pieces: pp. 18, 19, 20
123 E. 19th Street: pp. 142-3
Nine-Point Plane: p. 19
Pool: p. 74
Rhapsody: pp. 22-27
Sad and Happy Tidal Wave: p. 146
Series VIII (Parabolas): p. 41
17 White Street: p. 2
Shadow: pp. 156-157
Squaring: p. 43
Sunrise, Sunset II: p. 148
Swimmer Lost at Night (for Tom Hess):
p. 147
Swimmers and Rafts, Ellipse: pp. 150-151
Swimmers and Rafts, Rain: p. 60
Swimmers at Dawn, Noon and Dusk:
pp. 54-55
Swimmers Atlanta (installation view):
pp. 90-91
Swimmers Atlanta: Boat: p. 93
Swimmers Atlanta: Flare: p. 92
Swimmers Atlanta: Seaweed: p. 78
Termino Avenue: p. 145
The Garden: pp. 115, 116, 117, 118, 119
392 Broadway: pp. 52-53
To the Island: pp. 125, 126, 127
Traveling Line: p. 18
27 Howard Street/Day and Night: p. 144
2 Priory Walk: p. 141
2001: p. 19
Up the Creek: pp. 121, 122, 123
Water at Sunset, Swimmers at Sunrise:
p. 149
Wind: pp. 68-70
Volvo Commission: pp. 130, 131, 132, 133,
134, 135, 137